NO EXPERIENCE REQUIRED!

WaTeRCOLoR

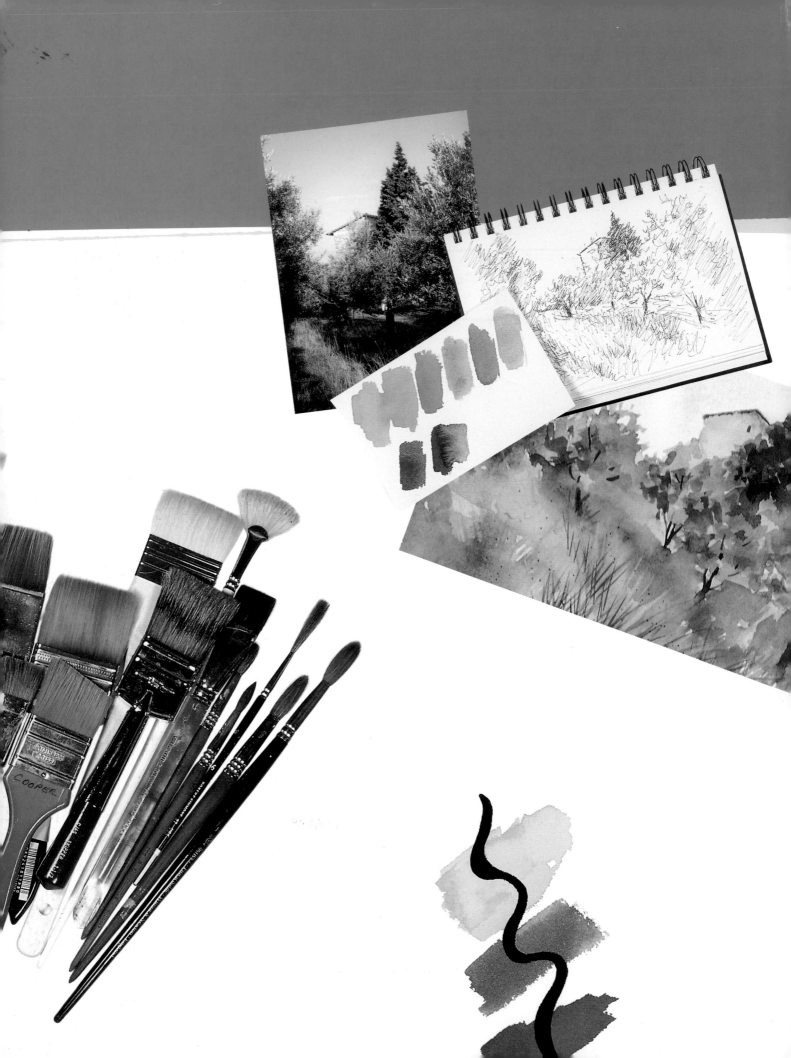

NO EXPERIENCE REQUIRED!

WaTeRCOLOR

Carol Cooper

NORTH LIGHT BOOKS

CINCINNATI, OHIO

www.artistsnetwork.com

Dedication

This book is dedicated to my wild, funny and talented family whose love and support sustains me: my parents, Jack and Margaret Williams; my sister and brother-in-law, Linda and Matt Dailey; my niece, Jennifer Dailey; my nephew and his wife, Jason and Wende Dailey and their daughter, Mina Dailey; and my sweet Rocky.

Library of Congress Cataloging in Publication Data
Cooper, Carol (Carol Williams).
 No experience required: watercolor / Carol Cooper.
 p. cm
 Includes index.
 ISBN 1-58180-471-7 (pbk. : alk. paper)
 1. Watercolor painting—Technique. I. Title: Watercolor. II. Title.

ND2420. C635 2004
751.42'2—dc22 2003070207

Edited by Christina Xenos and Layne Vanover
Production edited by Layne Vanover
Art direction by Wendy Dunning
Interior design and production by Barb Matulionis
Production coordinated by Mark Griffin

METRIC CONVERSION CHART

To convert	to	multiply by
Inches	Centimeters	2.54
Centimeters	Inches	0.4
Feet	Centimeters	30.5
Centimeters	Feet	0.03
Yards	Meters	0.9
Meters	Yards	1.1
Sq. Inches	Sq. Centimeters	6.45
Sq. Centimeters	Sq. Inches	0.16
Sq. Feet	Sq. Meters	0.09
Sq. Meters	Sq. Feet	10.8
Sq. Yards	Sq. Meters	0.8
Sq. Meters	Sq. Yards	1.2
Pounds	Kilograms	0.45
Kilograms	Pounds	2.2
Ounces	Grams	28.4
Grams	Ounces	0.04

About the Author

Carol Williams Cooper is an innovative artist and a creative master teacher whose award-winning artwork is eclectic in both style and subject matter. Cooper has participated in many group and solo exhibitions on a local, regional, national and international level. Her artwork appears in private and corporate collections around the world.

Cooper has two degrees in art. She earned her undergraduate degree from Sam Houston State University in Huntsville, Texas and her master's degree from Texas Woman's University in Denton, Texas. In addition to her formal education, Cooper has studied watercolor with numerous professional artists across the country and abroad for many years.

Having taught high school art for 13 years (in Australia and Texas), Cooper presently teaches art at NorthWest Arkansas Community College in Bentonville, Arkansas. In addition to her college teaching, Cooper is a popular workshop instructor. Carol Cooper currently lives in Northwest Arkansas, where natural beauty provides a constant source of inspiration.

Jason Dailey Photography

Acknowledgments

My thanks go to my editors at F+W Publications, Maria Tuttle, Christina Xenos and Layne Vanover, whose insightful guidance and care never wavered, and also to Pamela Wissman who recommended me for this book.

I wish to express my sincerest gratitude to all of my instructors from both the past and present who have inspired me to paint, including my father. I thank my mother for buying my first art supplies and easel when I was 13 years old and for her belief in me as an artist. My thanks also to all of my students throughout the years who continually amaze and inspire me with their creative ideas and knowledge. Thanks for the great energy exchange!

I am grateful to Victor Chalfant, Steve Cooper and Jason Dailey, who unselfishly provided photography assistance and expertise. Thanks to the staff at Bedford Camera and Video in Rogers, Arkansas, for their help and advice. And of course, thanks to my friends and family who constantly believed in me and this project!

Table of Contents

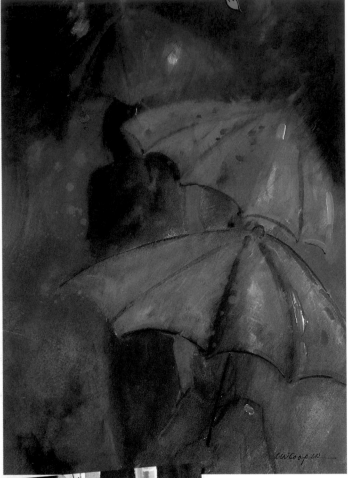

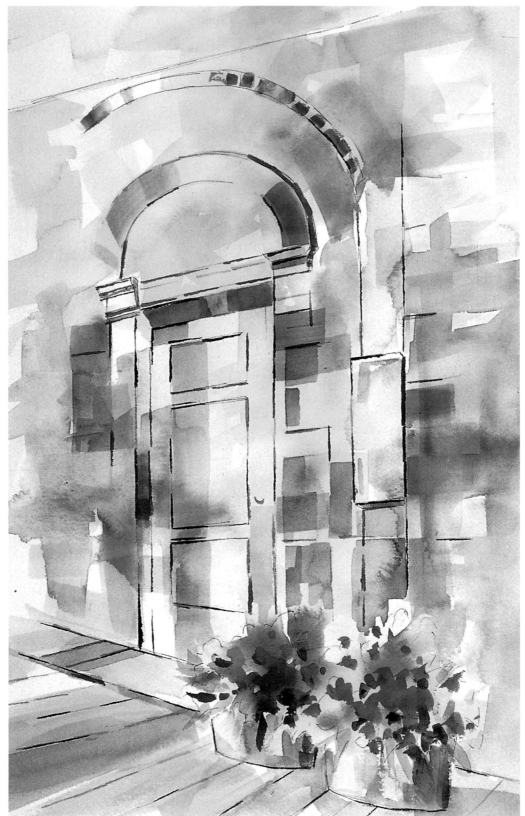

DOORWAY
19" x 12" (48cm x 30cm)

Introduction

Watercolor is a journey of exploration and expression. I have always been attracted to the beauty of watercolor, and this captivating medium now inhabits a lot of heart-space in me. The flowing brilliant colors and endless possibilities make watercolor exciting.

I am so pleased to be a part of your introduction to this versatile and spirited medium. Learning to work in watercolor is an acquired skill. Loads of natural talent are great to have, of course, but are not a pre-requisite to develop into a painter of substance. The keys to acquiring skill are determination, persistence, study and practice, practice, practice! Hey, don't forget to lighten up once in a while— have fun, play! Allow your creative spirit to flow and dance.

This book is a foundation—a place to start. Throughout the book I will offer skill-building information that will help you gain confidence with your watercolors. Once you gain some confidence and learn to trust your own artistic sensibilities, you will be able to break any rules you wish. Eventually you will be able to sift through ideas, styles, subjects and color schemes, keeping only those that work for you and releasing the rest. The following are a list of creative sparks to keep in mind as you continue to grow and change on your artistic journey.

Passion
Have a passion for your subject or colors. Loving what you do will help breathe life into your paintings.

Discipline
Dedicate yourself to becoming better and constantly improving your skills. Learn, read, study, practice and create on a regular basis.

Possibility
Look around you at all the possibilities for subject matter, style and design. Become more observant of your world and your feelings.

Interpretation
Learn to interpret scenes rather than just report them. This statement goes to the heart of personal expression.

Imagination
Feel free to imagine something different. Imagine subjects, variations and combinations. Have fun!

Intuition/Trust
Use subjects, colors and styles that work for you on the intuitive level. Learn to trust yourself and your choices. Seek opinions of your work from people you trust.

Courage
Have the courage to act on your decisions, move forward and take risks. Don't give up too easily on your paintings!

Getting Started

Gathering your supplies is a fun and necessary part of starting your watercolor journey. In this chapter I will discuss my top recommendations for brushes, types of paints, palettes and paper. Miscellaneous supplies and a complete shopping list of all materials you will need to complete the exercises in this book are mentioned at the end of the chapter.

Staying organized is essential to a painter. Your best bet is to buy a tote bag with a few side pockets or some other type of container that will hold most of your supplies. Keeping all your supplies together in a portable container will make it easier for you to work on location or attend classes and workshops. If your painting space at home is minimal, a tote bag can also act as a storage unit. If your supplies are organized and easily available, you are more likely to paint whether on location or at home. Watercolor painters can paint anywhere!

The following pages quickly and clearly explain what's out there in terms of materials. Learning about your materials and practicing with them are the first steps in building watercolor skills.

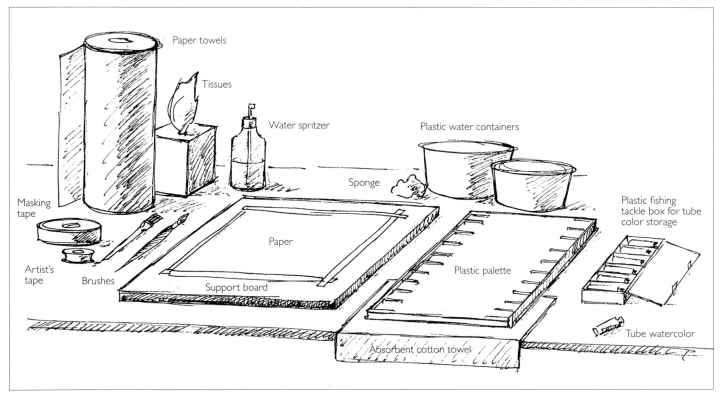

Explore the World of Watercolor Materials

Brush Basics

Brushes come in a wide variety of types and sizes, so making a choice can be a challenge. First, make sure the brushes you buy are suitable for watercolor. To help narrow the field, start with two versatile watercolor brushes: a no. 8 round and a 1-inch (25mm) flat. Collecting a large number of brushes is an option, not a necessity. Besides flats and rounds, there are many types of watercolor brushes available. Each type of brush has its own special capability. Following is a short list of useful brushes.

QUICK TIP

BOOST YOUR BRUSH I.Q.

- Good brushes snap back into their original shape after wetting.
- Don't let brushes soak in water for a long time. The ferrule could loosen from the handle and cause permanent hair loss—for your brush, that is!
- Clean your brushes with cool tap water. Flick the excess water off your brushes and help them recover their natural shape by wiping with a soft absorbent cloth.
- Avoid touching the hairs with your fingers to prevent your natural oils from getting onto the brush hairs.
- Store your brushes bristles up in a container or holder to prevent the hairs from crimping or folding.

Fan: A good brush for blending and creating grasses and wood grains.

Filbert: Similar to a flat brush; the filbert has corners that are slightly rounded and are good for eliminating hard edges.

Flat: An essential brush that has a flat, rectangular head and long filaments.

Hake (pronounced hah-kay): This Asian brush is fairly flat and comes in many widths. It works well for applying broad washes or gesso. A hake is also good for removing bits of erasure from your work.

Liner: The long hairs of this brush allow you to paint long, continuous, thin lines.

Mop: A large round brush that holds a great deal of water and can cover a big area quickly.

Rigger: Similar to a liner, the rigger is used for fine lines and details.

Round: Another essential brush with a round, pointed tip.

WORDS TO KNOW

FERRULE The metal portion of the brush that fastens the hairs to the handle.

Discover Brush Traits

Brushes are made with natural hair, synthetic fibers and filaments or a blend of natural and synthetic bristles. In the round brush, natural hairs hold more water and pigment and usually make a good point. Kolinsky sable and red sable are the best of the natural hair brushes. Synthetic fibers and blends of synthetic and natural hairs are less expensive, but can still work well.

| fan | flat | filbert | hake | liner | mop | rigger | round |

The Round Brush

Round brushes have a hair arrangement that is rounded at the base and ends in a natural-shaped point or tip. They are multipurpose and indispensable, as they are capable of creating a wide variety of effects from fine lines to broad washes. Their shape lends well to natural subjects such as landscapes, florals and figures, but these versatile brushes can be used for almost any subject, making them a staple among watercolor artists.

Round brushes come in many sizes ranging from 000 (very small) to 26 (very large). There is no exact standard for round brushes, so a no. 8 round could be slightly larger or smaller from one manufacturer to another.

Test Drive Your Round Brush
The round brush is capable of creating many types of strokes. Experiment with yours to see some of the possibilities you can create. Just load your brush with a juicy mixture of paint and water. Remember: each of your brushes is capable of a wide variety of strokes.

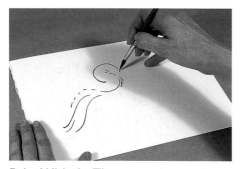

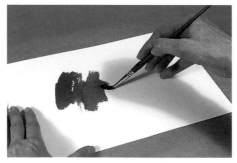

Paint With the Tip
Create fine lines, dashes and dots by holding the brush nearly perpendicular to the paper's surface. For more control, hold the brush close to the metal ferrule. I like to place my little finger on the paper to steady my hand and the brush. The closer your hand is to the ferrule, the tighter and more controlled your stroke is. Conversely, holding the brush at the end of the handle produces a looser stroke.

Paint With the Body of the Brush
You can cover a large area with a round brush by using the body of the brush. To create thick lines and fuller strokes, simply press the body of the brush down on the paper. On the other hand, if you want to create fine lines, pull the body of the brush away from the paper and use the tip.

Experiment Creating Different Effects
A splayed brush, where the hairs on the tip of the brush are spread apart with your fingers, has very little water in it. It is used for textural effects.

The Flat Brush

Flat brushes have a hair arrangement that is pressed flat at the base. They perform many functions such as applying washes and glazes, creating textures and lifting color. Flat brushes are a suitable choice if you want to cover a large area quickly. The size of a flat brush refers to the width of the hairs from side to side. For example, a 1-inch flat measures one inch across (25mm). Flats generally range from ¼-inch (6mm) to 2-inches (51mm). For beginners, I recommend a 1-inch (25mm) flat that is about one inch in length as well.

Test Drive Your Flat Brush
Try some of the same movements, twists and gestures with your flat brush that you attempted with your round brush. A flat brush is very versatile and is not limited to just big square strokes.

Paint Flat Strokes
To create a full flat stroke, hold the brush almost perpendicular to your paper. Create lines by touching the full length of the flat-edged tip of your brush to the paper. Holding your hand close to the metal ferrule gives you more control over these strokes.

Paint Loose Strokes
For a looser, less controlled stroke, move your hand toward the end of the handle.

Produce a Variety of Strokes
Use the full edge of the flat brush to produce a variety of strokes. Paint with the corner to produce dots and dashes. Push, dab, twirl, drag and flick your brush. Splay your brush hairs to create a highly textured look.

Paints

Watercolor paints come in tubes, cakes, pans, liquids, powders and pencils. This book primarily focuses on tube colors. However, when working on location, I enjoy using the pan colors occasionally because of their size and convenience. I use liquids and pencils primarily in my more experimental works.

Preferred Paints

I most often work with tube colors in the studio because they provide versatility. I prefer tubes for several reasons:

- The accessibility and choices of tube colors.
- The ease of creating glorious color combinations on my palette.
- The consistency of the tube paint itself.
- The choice of applying the paint thinly or thickly on the paper.
- The ability to mix large amounts of a color quickly.
- I've used them for the past twenty-five years!

Grades

The two basic grades of watercolor paints are student grade and professional/artist grade. Student-grade paint usually has less pigment strength and more fillers, making it less expensive. The colors of student-grade paint can be less intense and less vibrant than the professional grade. When shopping, you will notice the term *Artist's* is usually listed on the label of professional-grade tube paint. Price is another indication of what grade you are purchasing.

WORDS TO KNOW

GOUACHE Gouache is an opaque watercolor comprised of the same ingredients as regular watercolor paint, except it contains a chalky substance that makes it opaque. Gouache has a stronger covering ability than regular watercolor because of its opacity.

QUICK TIP

REVIVING PAINT

When using tube paints, revive paint that has dried in the wells by spritzing water over it. This will save your brush tips from wear. If your paints appear to be crumbling in the wells, a drop of gum arabic or glycerin with a spritz of water can help rejuvenate them. Ideally, it is best to use fresh paint each time you paint.

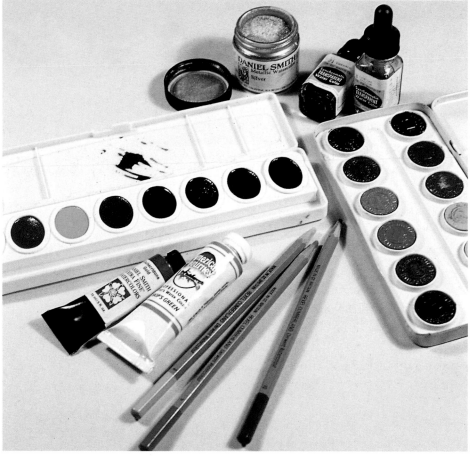

Paint Forms
Watercolor paints come in numerous forms. Although tubes are the most commonly used form of watercolor paint, this medium can also be found in the form of cakes, pans, powders, liquids and pencils.

Painting With Pans

The following steps illustrate the ease of working with semimoist pan colors. There are several types of pan sets and half-pan sets produced by various paint manufacturers. With these sets you can easily replenish colors or create your own palette of colors. Such sets are sold in art stores and through art catalogs. As mentioned earlier, pan sets are great to take on location because of their convenient size. This activity uses a Prang set, which is widely available and offers bright, clean colors.

MATERIALS

PAPER
140-lb. (300gsm) cold-pressed watercolor paper

WATERCOLORS
Pan set

BRUSHES
No. 8 round

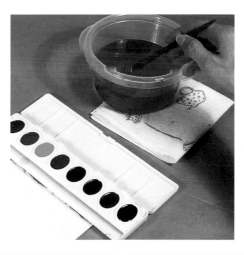

1 Wet the Brush
Wet a no. 8 round to prepare it for the color.

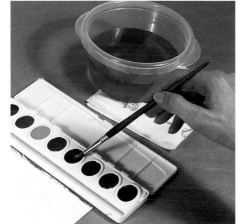

2 Load the Brush With Color
Load your brush with paint, moving it back and forth in the pan. Your brush should not dig into the paint, but rather just skim the surface of the color.

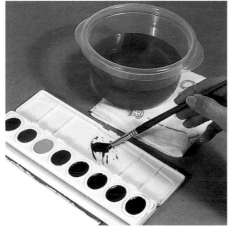

3 Mix Color
Use the plastic lid of your paints to mix the desired consistency of paint.

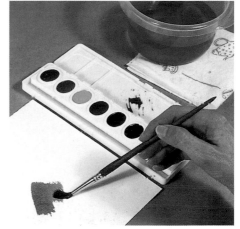

4 Apply the Mixture to Paper
Practice applying several smooth and even strokes to your watercolor paper.

Palette

The purpose of a palette is to allow quick and easy access to your paints while you are painting. It also provides you with a mixing surface and can help to protect unused portions of paint. You can use any nonabsorbent, smooth white surface for your palette. For instance, a white china or Styrofoam plate will work if you're in a pinch. However, for more efficiency and ease I recommend a white plastic palette with some form of wells and a lid. I prefer rectangular-shaped palettes over the round ones. I have used these throughout my career, as I find them more accessible and easy to handle. The rectangular shape also fits nicely in my art bag.

There are some wonderful smaller rectangular palettes made from enamel or aluminum that work as well and are great for travel. Some of these are even designed with thumb holes for easy handling while painting. You can find a variety of palettes in art stores or catalogs.

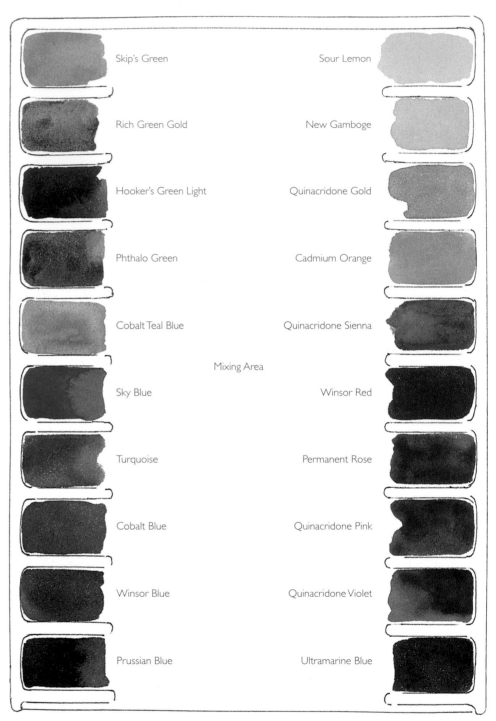

Skip's Green

Rich Green Gold

Hooker's Green Light

Phthalo Green

Cobalt Teal Blue

Sky Blue

Turquoise

Cobalt Blue

Winsor Blue

Prussian Blue

Mixing Area

Sour Lemon

New Gamboge

Quinacridone Gold

Cadmium Orange

Quinacridone Sienna

Winsor Red

Permanent Rose

Quinacridone Pink

Quinacridone Violet

Ultramarine Blue

Sample Palette Layout
I arrange my palette as follows: yellows, oranges, earth tones, reds, pinks, blues, blue-greens and greens. To ease your journey into watercolor, I've added more colors to my standard palette so you don't have to worry about mixing additional colors. (See page 19 for a complete list of colors used for demonstrations.) As you become more familiar with the medium, you'll eventually want to learn how to mix color. However, as you begin, tube colors provide you with the convenience to start painting right away.

Although many of the same tube color names can be found among different brands, the colors themselves may vary a bit. Conversely, some tube color names are exclusive to a particular brand, but you may be able to match the color to one of another name in a different brand.

Preparing a Palette

Once you've acquired your tube paints and palette, squeezing the fresh, brilliant colors into the wells is your next step. With a little organization and planning, your palette will be easy to use. Randomly placing colors in the wells may work for a while, but eventually your palette will become very confusing and frustrating unless you organize the placement of your paints. Follow these simple steps and you will be on your way to success!

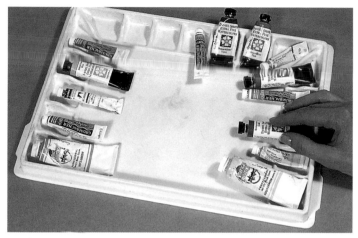

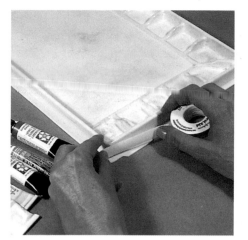

1 Choose Your Paint Order

Before you begin squeezing out paint, decide how you will arrange your colors by laying the tubes in the wells. Any placement system that works for you is fine. A standard arrangement of colors (in clockwise progression) is yellows, oranges, reds, violets, blues, greens and earth tones. Grouping colors in this way will allow you to find them easily as you paint.

2 Tape the Perimeter of Your Palette

Remove tubes from the wells and lay them on a table in the order you decided. Put a half inch (12mm) of white artist's tape around the perimeter of your palette.

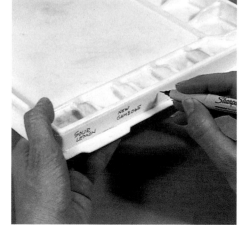

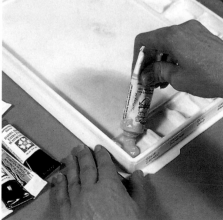

4 Add Paint

Squeeze a portion of paint into the wells. Clean your mixing area often to ensure bright, clean mixtures. If the wells get muddy, place a brush full of clean water into the well and lift out the mud with the brush or a paper towel. At the end of a session, clean your mixing area and place the lid on your palette.

3 Label the Wells

Label each well with its corresponding color using a waterproof felt-tip pen. This helps you learn your paint names and reduces confusion. You can put other notes (in code) in addition to the paint names, such as paint brands and the paint properties discussed in chapter 2.

Paper

Many factors must be taken into account when choosing watercolor paper. Different brands, weights and textures all influence your painting. Thus, taking the time to find the right type of paper for your painting is well worth it.

There are many quality brands of watercolor paper available through art stores and art catalogs. You can find watercolor paper in a single sheet, pack, pad, spiral notebook, block or on a roll. Watercolor board is also available. A standard full-size sheet of paper measures 22" x 30" (56cm x 76cm). It also comes in an elephant size, which is 26" x 40" (66cm x 102cm). The rolls of paper are usually 48" x 10 yards (121cm x 9m) to accommodate large or odd-sized works.

Watercolor paper also comes in a variety of weights or thicknesses. A sheet of 140-lb. (300gsm) watercolor paper is considered a standard medium-weight paper, while a sheet of 300-lb. (640gsm) watercolor paper is very thick.

A final factor to consider when you're choosing paper is texture. There are three basic types of surface textures (or tooth) available in watercolor paper: hot-pressed, cold-pressed and rough. The following illustrations explore the differences between these surface textures and discuss uses for each particular type.

WORDS TO KNOW

PRESSED PAPER During the paper-making process, paper is passed through rollers or pressed. The hot-pressed paper is passed through heated rollers that smooth it. Both cold-pressed and rough paper are passed through unheated rollers that leave a texture.

Hot-Pressed Paper

This paper can be a bit challenging to a beginner, as it has little or no tooth (texture) to hold the paint in place. Water and paint tend to skate around on the smooth surface creating wonderfully unpredictable drying patterns. This particular paper is great for flowers because the drying patterns are very organic.

Cold-Pressed Paper

This paper has a medium-textured surface and works well with most techniques. Its texture can be minimized or enhanced according to the amount of water used. If you drag a fairly dry brush full of paint across dry portions of paper, the texture will show through. The slight valleys hold the paint in place nicely. Most of the examples in this book are on 140-lb. (300gsm) cold-pressed paper.

Rough Paper

This paper has the most textured surface and is very durable. The rough texture lends itself well to shimmery effects of light on water. This effect was created by dragging a fairly dry flat brush filled with paint across dry paper.

QUICK TIP

POINTERS FOR PRESERVING YOUR PAINTINGS

- Keep finished paintings out of direct sunlight to prevent them from fading.
- Store paintings or unused paper in an acid-free folder or portfolio. If those are not available, storing paper in a cool, dry place will help tremendously with preservation.
- Collect the silica packets that come with new shoes and drop them in your paper box, drawer or folder to reduce moisture and prevent mold.

Additional Supplies

Along with brushes, paints, a palette and paper, you'll need a few more materials to complete your watercolor supplies.

Artist's tape (or masking tape): Using tape secures your paper while you paint and gives you a clean edge when you are finished. It works well with paper that is 11" x 15" (28cm x 38cm) and smaller. Place half of the width of your tape on your paper and the other half on your support board. Run the tape around the perimeter of the paper. To avoid tearing, peel the tape away from your work after your painting is dry. For smaller works use ½-inch (1cm) masking tape.

Bulldog clips: Metal clips are a quick and easy way to secure your paper. Work with a board that is only slightly larger than your paper so the clips can easily hold the paper.

Eraser: I use a white plastic variety or a kneaded rubber eraser.

Hair dryer: This speeds up the paint-drying process.

Paper towels and tissues: Use them for easy clean up and sometimes to lift paint.

Pencils: Use a 2HB pencil (this can be substituted with a regular no. 2 pencil) to make the initial drawings on your watercolor paper. I like mechanical pencils with a soft white eraser. If your pencil lead is too soft (3B and up) it will lift and smear while you paint. Avoid using hard lead because it will leave indentations in your paper.

Sketchbook: As a beginning watercolor artist, it's important to start keeping a record of ideas, scenes and notes in a sketchbook. Document details like sounds, smells, time of day and even weather conditions! You can also use your sketchbook as a journal, exploring your thoughts, feelings and dreams.

Sponges: A variety of sponges can be used to lift paint from the paper, discharge paint from a brush and assist in cleanups.

Spray bottle: Whether you want to revive dried paint on your palette or create special effects, spray bottles make excellent tools. You can recycle small plastic hair spray bottles, but be sure to re-label them.

Support board: This board provides a sturdy backing while painting. When paper is taped, clipped or stapled, it will remain relatively flat. I recommend a stiff cardboard or foamcore board for smaller works. For larger works that need stapling, use plywood or Gator board. Stapling can be done on wet or dry paper. If you wet your paper first, remove the excess water with an absorbent cotton towel before stapling.

Tackle box: These plastic boxes come in all sizes. I like to use plastic fishing tackle boxes for my paint tube storage. The small ones tuck easily into a tote bag.

Texture makers: Many objects can score or scrape wet paint such as a credit card fragment, a brush end or a craft knife. Corks also make interesting stamped shapes.

Water containers: Use two small plastic containers, one for mixing colors and the other for holding water. You may want to purchase a small divided water container.

Waterproof black felt-tip pen: Use a pen in your sketchbook or in your paintings to add character and detail.

SHOPPING LIST

To complete the exercises in this book, you will need the following materials:

PAPER
140-lb. (300gsm) cold-pressed watercolor paper

BRUSHES
No. 8 round
1-inch (25mm) flat

WATERCOLORS
Burnt Sienna • Cadmium Orange • Cerulean Blue • Cobalt Blue • Cobalt Teal Blue
Halloween Orange (Cheap Joe's) • Hooker's Green • Hooker's Green Light • Indian Yellow
Lemon Yellow • New Gamboge • Opera (Holbein gouache) • Phthalo Blue
Phthalo Green • Pomegranate (Cheap Joe's) • Prussian Blue • Quinacridone Gold
Quinacridone Pink • Quinacridone Red • Quinacridone Sienna • Quinacridone Violet
Red Hot Momma (Cheap Joe's) • Rich Green Gold • Skip's Green (Cheap Joe's)
Sky Blue • Sour Lemon (Cheap Joe's) • True Green (Cheap Joe's) • Turquoise
Ultramarine Blue • Winsor Blue • Winsor Green • Winsor Red • Winsor Yellow

OTHER
Artist's tape (or masking tape) • Bulldog clips • Eraser • Hair dryer • HB pencil
Paper towels and tissues • Sponges • Spray bottle • Support board • Staples
Texture makers (see chapter 8) • Water containers • Waterproof black felt-tip pen

Basic Color Concepts and Techniques

Watercolor is surprising and at times mysterious; both these characteristics contribute to its intriguing appeal. Some think that watercolor is too unpredictable, uncontrollable, and worst of all, unforgiving. True, there are some attributes of watercolor that invite unplanned effects, but those characteristics are the very ones that make it fun and exciting. Learning the color concepts, paint properties and basic watercolor techniques found in this chapter will begin to quiet such fears, providing you with ways to predict most outcomes and correct mistakes if necessary. With study and practice you can learn to work quite successfully with this maverick medium. Mixing mastery with mystery creates powerful art!

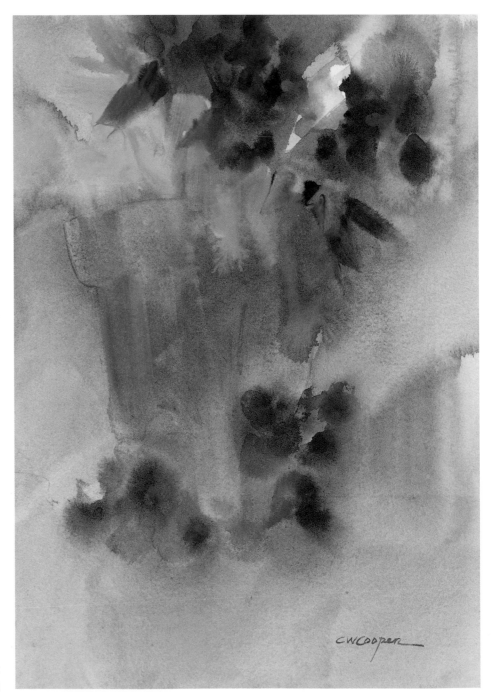

DUSK
15" x 11" (38cm x 28cm)

Color 101

"What colors should I use?" This is a frequently asked question from beginners. Color provides information in a painting and is a very personal expression of the artist. With so many options, variations and schemes available, the possibilities can seem overwhelming. Learning about color theory will aid you in your color decisions.

COLOR SCHEME A color scheme is a plan for the colors in your painting. Some color schemes are monochromatic (one color), analogous (colors next to each other on the color wheel), complementary (colors that are opposite each other on the color wheel), and so on. There are many possibilities for color schemes. Choosing a rather short list of arbitrary colors is also considered a color scheme and is often referred to as a limited palette. I recommend purchasing a color wheel to help you understand your color scheme options.

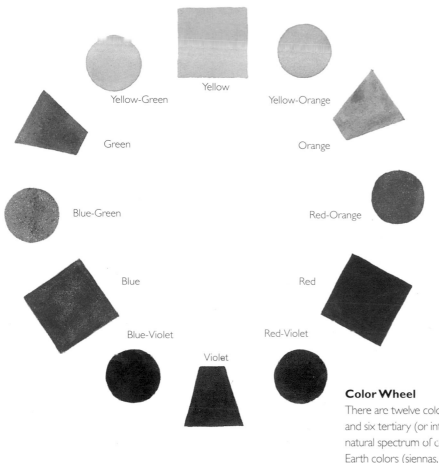

Color Wheel
There are twelve colors on the color wheel: three primary, three secondary and six tertiary (or intermediate) colors. The color wheel is based on the natural spectrum of colors that is created when light passes through a prism. Earth colors (siennas, umbers and oxides) and neutrals (whites, blacks and grays) are not represented on the standard color wheel.

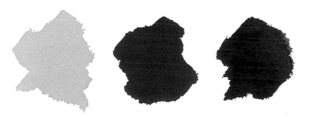

Primary Colors
The primary colors are yellow, red and blue. It is from these three colors that all other colors are made. The primary colors are equidistant from each other on the color wheel and form a triad.

Secondary Colors
The secondary colors are green, violet and orange. Each one is made from mixing two primary colors together: yellow + red = orange; red + blue = violet; yellow + blue = green.

Tertiary Colors

Tertiary or intermediate colors are made from mixing one primary color and its neighboring secondary color. For example yellow + green = yellow-green.

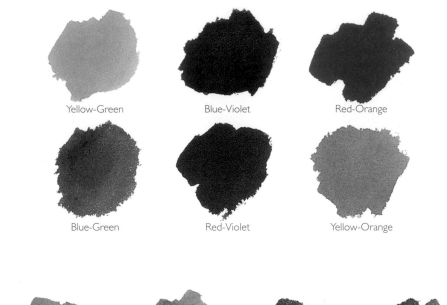

Yellow-Green Blue-Violet Red-Orange

Blue-Green Red-Violet Yellow-Orange

Earth Colors

Earth colors (ochre, siennas, umbers, etc.) are most often made from natural substances from the earth like clay and soil. These colors are more subdued than the vivid ones found on the color wheel.

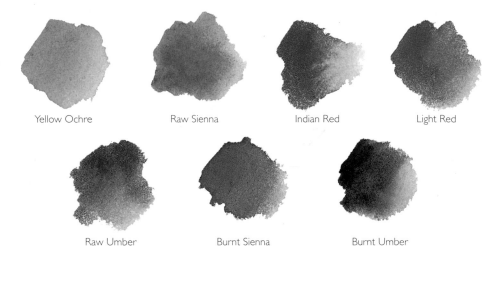

Yellow Ochre Raw Sienna Indian Red Light Red

Raw Umber Burnt Sienna Burnt Umber

WORDS TO KNOW

COMPLEMENTS Complementary colors are opposite each other on the color wheel. When complements are placed next to each other in a painting, they brighten each other. When they are mixed together they dull each other, making a gray.

Neutrals

Pure black, white and gray are true neutrals. They are achromatic (without color). However, blacks and grays can be made from combining other colors, resulting in more colorful neutrals.

Color Characteristics

Color characteristics create contrast, variety and movement in a painting. Whether you're planning a composition or are in the process of painting one, you will continually make decisions as you paint concerning four characteristics of color: *hue, value, intensity and temperature.*

Hue

Hue is the generic name of a color such as red, blue, yellow, red-violet, green and so on. While painting, one of your choices is to make a hue change, or going to a completely new color in another section of your work.

Value

Value refers to the lightness or darkness of a color. A color can be light, mid-light, middle, mid-dark or dark in value. Hues lightened with water or white are *tints.* Hues darkened with black, brown or simply a darker color are called *shades.* Value changes create the most contrast and highest impact when darks are placed near light areas.

Intensity

Intensity refers to the brightness or dullness of a color. A low-intensity color is a hue that has been muted (grayed, dulled, neutralized). A high-intensity color is one that is pure in hue, highly saturated and has not been dulled. Varying the intensity of colors in your painting adds subtlety and nuance.

Temperature

Temperature is the warmness or coolness of a color. In general, the warm colors are red, yellow and orange, and the cool colors are blue, green and violet. With regards to color movement, warm colors appear to advance (come forward) in a painting, and cool colors appear to recede (go back).

Temperature also refers to the warm and cool variations within each color. For example there are warm and cool reds, blues, yellows, pinks and so on. A color's temperature is always relative to the color next to it in a painting or on a chart. My palette of colors on page 16 contains a warm and cool version of the basic colors.

Value
Every color has a range of value. Moving lights, darks and midtones around your painting is a basic organizational concept.

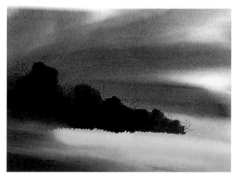

Intensity
You can use pure colors and their muted (grayed) counterparts to create movement and contrast in a painting. Bright colors will advance, while muted colors will recede.

Cadmium Red Phthalo Red

A Closer Look at Temperature
Each color has cool and warm variations. This means that colors traditionally considered warm have cool variations and vice versa. For example, Cadmium Red contains a good deal of yellow, pushing it toward warmth. Phthalo Red, on the other hand, contains more blue, pushing it toward coolness. Thus, a color's temperature is always relative to the color next to it in a painting or on a chart.

Hue
Hue is the generic name of a color found on the color wheel (page 21) such as red, blue or green. There are twelve basic hues on the color wheel. Each hue has many variations in color.

Paint Properties

In addition to knowing the characteristics of color, it is important to understand the nature of your paints. Each tube of watercolor paint has certain properties. These properties include *permanence, transparency/opacity, staining ability and granulation*. Reading books, making notes and creating charts are ways to learn the properties of your paint. For example, Phthalo Blue is a permanent, strong-staining, transparent paint. Ultramarine Blue is a permanent, somewhat staining, semi-transparent, granulating paint. With time, this information will prove useful.

Permanence

Permanence or lightfastness refers to the ability of paint to retain its original color over time. Durability ranges are: excellent (will not fade), good, moderate and fugitive (will fade). Most paint manufacturers list the lightfastness rating on the side of the paint tubes. When shopping, look for the top two ratings.

Transparency/Opacity

Transparency and opacity are concerned with the same issue: How much does light penetrate the paint color? Paint colors are ranked on a scale from transparent to opaque. Transparent paint allows light to penetrate the paint and bounce off the underlying white surface of the paper. Transparent paints are ideal for glazing, or the layering of colors, because they allow the underlying colors to show through. Also, you can often mix several transparent paints together before the mixture becomes muddy.

Opacity allows little light to penetrate the paint, so the light bounce from the paper is reduced. When applied over another layer of paint, opaque paint has strong covering power. In mixtures,

Transparency and Opacity
The covering ability is apparent in these transparent paints (left) and opaque paints (right). Transparent paints allow light to penetrate through to the paper while opaque paints deflect the light. These paints were applied over a streak of black India ink.

opaques are rather bossy and tend to push weaker colors around. Mixing more than two opaques together can produce a muddy look. However, if you need intense color quickly, an opaque is a good choice.

Staining Ability

Staining ability refers to a paint's ability to either remain on the surface of the paper or sink into its fibers. Paints range from nonstaining to strong staining. A strong-staining color is more challenging to lift off the paper. If used as a glaze, a staining color drastically affects the paint below it. In mixtures, a small amount of a strong staining color will go a long way.

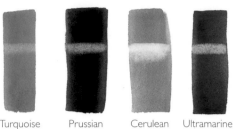

Turquoise | Prussian Blue | Cerulean Blue | Ultramarine Blue

Staining Ability
This chart gauges a paint's staining potential. After the paint was dry, I lifted a small band of color with a damp 1-inch (25mm) flat brush, then blotted the area with a paper towel. Turquoise was the most staining, while Cerulean Blue was the least staining.

Granulation

Granulation results from sediment (coarser pigments) found in some paints. The sediment tends to settle in the small valleys of the paper, producing a slight textural effect.

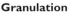

Granulation
This slightly textured painting contains a few of the granulating paint colors: Permanent Rose, Ultramarine Blue, Burnt Sienna and Cerulean Blue.

Pairing Paint With Brush

Mixing paint with water is the first step toward watercolor painting. Discovering the right amount of water and paint to use in order to achieve the desired effect is sometimes a trial and error procedure. In a short time, though, you will know just how much water your brush will hold and how much paint to use. Your first few painting sessions will begin to dispel any initial frustration you may have, replacing it with excitement. You can do it!

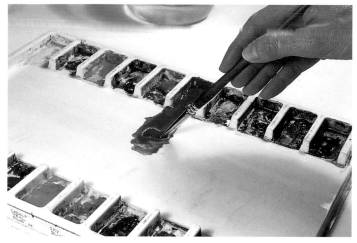

Load the Brush With Paint
Place your brush in a water container. Touch the brush to the lip of the container to release some water. This prevents you from flooding the paint well with too much water. Place your wet brush into your paint well and transfer some paint onto the mixing surface. Add more water for lighter colors and less water for stronger or darker colors. Keep in mind that paint dries lighter than it appears when applied.

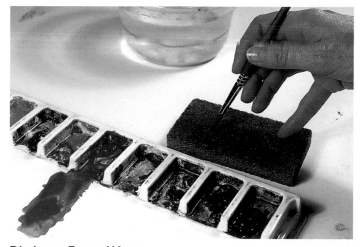

Discharge Excess Water
Discharge excess water from your brush by touching the tip of your brush to a damp sponge or paper towel.

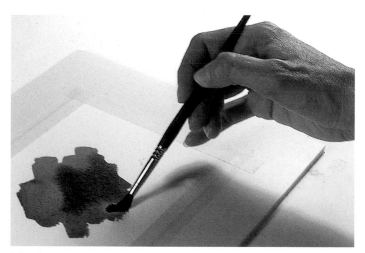

Mix Colors on Paper
Stroke a juicy color onto the paper. While wet, drop in another color mixed with water. A small amount of clear water can be dropped into the mixture to assist mixing. Use minimal brushstrokes when mixing on the paper so that your paint colors combine somewhat but retain some individuality as well. This step uses a wet-in-wet technique of applying paint that is discussed further on page 26.

QUICK TIP

TAPING AND TILTING
After taping your paper to the board, tilt the board at a 15° angle. This serves two purposes. One, you will be able to see your painting better and two, you will always know the direction your paint is going to flow. You can make an incline by stacking a book or two on your table and leaning your support against it. Some watercolorists prefer to work vertically on an easel, keeping an absorbent towel ready for the drips. Try different angles and see what works best for you.

5 Basic Watercolor Techniques

There are many watercolor techniques for applying paint that produce many different effects and textures. The five basic techniques are *wet-in-wet*, *wet-on-dry*, *drybrush*, *washes* and *glazes*.

Wet-in-Wet

Use this method to achieve a soft-edged look. In this technique wet paint is applied to wet paper. A variety of brushes can be used for this method. To cover large areas use a flat or a large mop brush. For smaller areas, use a no. 8 round. Remember, as long as the paper glistens, you can add water and paint using the wet-in-wet technique without forming a bloom (see page 29).

Wet-on-Dry

This method involves working with wet paint on dry paper and results in hard edges unless the paint is softened with water or more paint. This is a more controlled technique than wet-on-wet, as the wet paint stays in place unless the paper is tilted or rapped to force a drip.

Drybrush

The drybrush technique is an extremely controlled technique, created by having paint and very little water on your brush. Drybrush is an excellent texture-maker in a painting. By dragging, wisping and tapping your brush across the paper, you will achieve some wonderful effects.

Paint Wet-in-Wet
When painting wet-in-wet, begin by wetting your paper using a no. 8 round. Next, add a color (here, Quinacridone Gold) to the wet paper. While the paper is still wet, immediately move on to adding more color.

Drop in More Color
Continuing the process, I dropped in Winsor Blue. Notice that the two colors mix slightly on the paper and form soft edges.

Paint Wet-on-Dry
In this example of wet-on-dry, I applied a few strokes of Quinacridone Violet on dry paper using a 1-inch (25mm) flat. This technique results in hard edges.

Soften a Few Edges
While the violet strokes were still wet, I quickly placed a stroke of Ultramarine Blue over the previous strokes. Notice how this softens the edges where the two colors merge. Untouched edges remain hard. You can also soften edges by brushing them with plain water rather than paint.

Experiment With a Dry Brush
Using a 1-inch (25mm) flat with very little water in it, I applied Quinacridone Sienna + Ultramarine Blue to the paper using upward, wisping strokes. To ensure a very dry brush, I touched the tip of the brush to a paper towel to discharge excess water. This stroke could represent grasses in a field or a person's hair.

Practice Drybrush With Splaying
Using a no. 8 round and very little water, I repeated the wisping strokes used in the previous example with Quinacridone Sienna + Ultramarine Blue. In this example, I splayed the hairs of the brush using my fingers to get this textured effect.

Washes

Washes are a staple of watercolor painting. They are most often used as an underpainting (a basecoat) or for large portions of sky and ground. A wash is simply a fluid, transparent layer of paint. There are three essential types of washes in watercolor painting. A *flat* wash is an evenly colored area with no variations of light or dark (no changes in value).

A *graded* wash, however, increases or decreases in strength of value. A *variegated* wash uses a variety of colors. This is a very versatile wash and can provide an unusual underpainting for many subjects.

Glazes

Glazes are thin layers of paint laid over dried layers of paint. You can glaze light over dark or dark over light. Glazing can slightly affect the color underneath or visually combine to create a completely different color. You can glaze many colors over one another if using transparent paint. However, there is a possibility of layering too many colors, which creates a muddy or overworked look.

Flat Wash
A flat wash is evenly colored with no variation in lightness or darkness. The word flat also describes its lack of depth.

Graded Wash
A graded wash lightens or darkens in value as it moves across the paper. Graded washes provide a sense of depth.

Variegated Wash
A variegated wash contains a variety of colors that flow together yet retain some of their individuality. The diverse possibilities of this wash provide both depth and interest.

Create the Foundation for the Glaze
I applied several strokes of Quinacridone Gold on dry paper and then allowed the paint to dry. (You can use a hair dryer to speed the process.)

Begin the Layering Process
Next, I applied a thin layer of Quinacridone Pink over the gold. Notice the beautiful orange color that was made where the two colors cross. I then allowed the pink layer to dry.

Complete the Glaze
Finally, I added a glaze of Cobalt Blue. Notice the beautiful muted gray that is formed where all three colors coincide. The gold, pink and blue that were used create green, orange and violet at times.

Practice Essential Washes

Basic washes are versatile techniques to learn and are essential to the watercolorist. As mentioned on the previous page, there are three types of washes: flat, graded and variegated. Washes can be used, for example, as an underpainting, for a subtle change within an object, or for large expanses of sky. Their uses are limitless. Practice the following washes on a few small taped-off squares about four inches (10cm) in size. After you feel confident on a small scale, create larger washes. Notice that the larger your washes, the broader and looser your arm movements must be.

Flat Wash

1 Begin a Flat Wash
Tape your paper to your board and tilt the board at a slight angle. Mix a large puddle of Ultramarine Blue and water on your palette. Load your brush with the juicy mixture. Apply the paint mixture to dry paper in a horizontal motion across the top, going from edge to edge of the paper. Gravity will work for you by forming a bead of paint mixture at the bottom of each stroke.

2 Paint Down the Paper
Reload your brush with the same paint mixture and repeat the stroke, overlapping the bottom edge (the bead of color) of the previous stroke while it is still wet. Avoid going back and forth over the same stroke, or streaks will result.

3 Remove Excess Water
If a bead of paint is left at the bottom edge of your paper, remove it with a paper towel or a fairly thirsty (damp) brush.

4 Final Result
The finished flat wash has very little, if any, variation from light to dark as it moves down the paper.

QUICK TIP

CORRECTIONS AND ADJUSTMENTS

It's been said that painting is just a series of corrections and adjustments. Let's look at some ways to correct and adjust!

To lift out wet paint: Immediately blot the area with a paper towel or tissue or flood it with water (using a brush or spritzer) and then blot.

To lift out dried paint: Scrub your paper with a damp 1-inch (25mm) flat to lift the paint, then blot with a paper towel or tissue.

To Adjust: Apply a rich dark staining color over a dried layer of paint to completely cover an unwanted area, or transform a color by applying a transparent glaze. Most often, though, it's okay to just leave unplanned drips, splatters or mistakes—they can give a painting character!

MATERIALS

PAPER
140-lb. (300gsm) cold-pressed watercolor paper

WATERCOLORS
Quinacridone Gold
Quinacridone Sienna
Ultramarine Blue

BRUSHES
1-inch (25mm) flat

Graded Wash

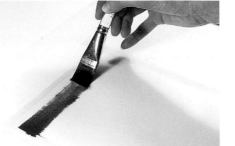

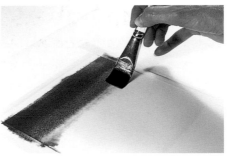

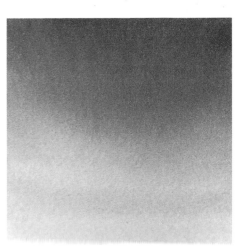

1 Begin a Graded Wash
Attach your paper to a board and tilt it at an angle. Place a stroke of clear water across the top of the paper. Load your brush with Ultramarine Blue. Apply a horizontal stroke across the top of the paper.

2 Paint Down the Paper
Clean your brush. While the previous stroke is still wet, apply a stroke of clean water overlapping the bottom bead that has formed at the bottom of the previous stroke. Repeat, moving down the paper.

3 Final Result
This finished wash is darker at the top and fades out to a lighter value toward the bottom of the paper. The tendrils of color that reach downward are caused by tilting the paper almost vertically after applying a few strokes of water.

Variegated Wash

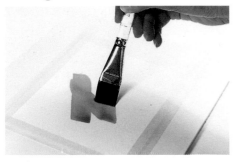

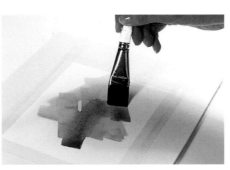

1 Begin a Variegated Wash
Mix some Quinacridone Gold and water on your palette. Place a few strokes of this mixture on your paper, immediately adding a few crisscross strokes of clean water to help move the paint around.

2 Add Additional Color
While the Quinacridone Gold is still wet, place some strokes of Quinacridone Sienna. Add a bit more water if the colors don't seem to be flowing. Remember, don't overmix the colors on your palette or paper.

WORDS TO KNOW

BLOOM Look closely at the finished variegated wash. When it dried, a small bloom developed in the lower right corner. A bloom (also called a blossom, backwash or cauliflower) forms when wet paint comes into contact with damp paper. Blooms are not necessarily a bad thing. If one forms and you wish to remove it, allow it to dry first. Then, gently lift the paint off the area with a damp, stiff bristle brush or a damp 1-inch (25mm) flat. Blooms just happen sometimes, but one way to avoid them is to be aware of the dampness of your paper and mop up excess paint along the edges so it doesn't re-enter the painting.

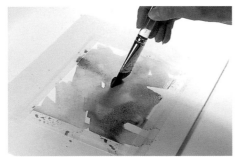

3 Continue Adding Color
While still wet, paint in a few strokes of Ultramarine Blue. Again, try not to overmix.

4 Final Result
In a finished variegated wash the colors should mix together in some areas and retain their own identity in others.

Combining Techniques

To give variety and interest to a painting artists often combine painting techniques. The following demonstration utilizes a variegated wash using a wet-on-dry method. It also employs the wet-in-wet method and splattering.

Italian Hillside
This photograph, taken at La Romita in Terni, Italy, is the inspiration for this painting.

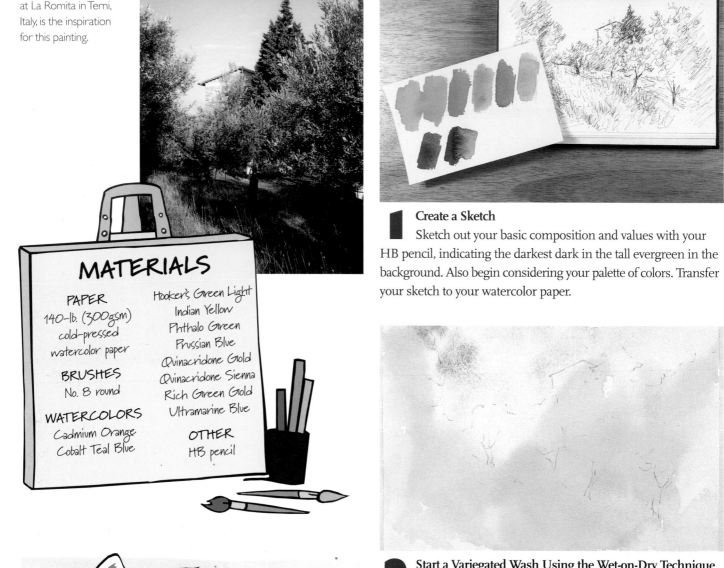

1 Create a Sketch

Sketch out your basic composition and values with your HB pencil, indicating the darkest dark in the tall evergreen in the background. Also begin considering your palette of colors. Transfer your sketch to your watercolor paper.

MATERIALS

PAPER
140-lb. (300gsm) cold-pressed watercolor paper

BRUSHES
No. 8 round

WATERCOLORS
Cadmium Orange
Cobalt Teal Blue

Hooker's Green Light
Indian Yellow
Phthalo Green
Prussian Blue
Quinacridone Gold
Quinacridone Sienna
Rich Green Gold
Ultramarine Blue

OTHER
HB pencil

2 Start a Variegated Wash Using the Wet-on-Dry Technique

Attach the paper to your support board. Crop the size of the paper using masking tape to create a 6" x 9" (15mm x 23mm) opening. Create a variegated wash by brushing in Quinacridone Gold with your no. 8 round, then add a few strokes of clear water using your flat to help it move around. Then add strokes of Ultramarine Blue and Cobalt Teal Blue. Allow the colors to mix somewhat on the paper. Let this dry.

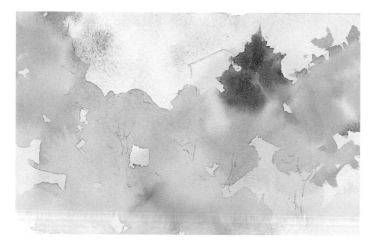

3 Lay In the Trees and Foreground With Wet-in-Wet Strokes
Using your no. 8 round, re-wet the tree areas and foreground with clean water. While wet, drop in Rich Green Gold, Hooker's Green Light and Ultramarine Blue in the trees. For the dark evergreen, float in some Prussian Blue, Quinacridone Gold and Quinacridone Sienna. In the foreground, float in some Indian Yellow. Allow your paper to dry.

4 Develop Trees and Foreground
Apply Rich Green Gold, Hooker's Green Light, Phthalo Green and Ultramarine Blue to the trees, using your no. 8 round. Use small strokes to give the appearance of foliage. Add water as you go to help some of the strokes blend. While this is still wet, drop some Ultramarine Blue into the darker trees on the left and right edges. Let this dry.

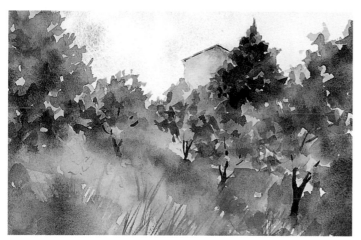

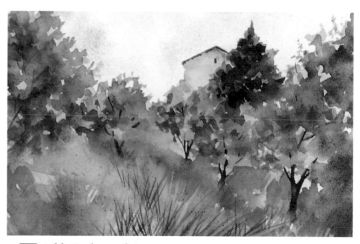

5 Add Glazes and Begin Details
Add some darker values of green to the trees by mixing your greens together and adding Ultramarine Blue + Prussian Blue until you get a dark green that you like. Apply this dark green to the trees with your no. 8 round, adding a bit of water as you go to help blend some strokes. For the tree trunks, mix Ultramarine Blue + Quinacridone Sienna using very little water. Place Indian Yellow on the chapel building. Drop a bit of Ultramarine Blue onto the right side of the chapel for a shadow effect. Drybrush a few upward strokes of grass in the foreground using Cadmium Orange.

6 Add Final Details
Using Ultramarine Blue + Quinacridone Sienna (adding very little water) create brown grasses in the foreground. Using that same brown, create a darker edge under the roof of the chapel. Add a bit more orange to the roof to suggest roof tiles. Add a small window for interest in the chapel using re-mixed brown or any dark value. Add more limbs in the trees using the same mixture. For a final touch, add some dark splatters using the brown mixture. Using a fairly dry mixture of paint and water, tap your brush across a pencil over the lower left foreground.

CHAPEL
6" x 9" (15cm x 23cm)

Painting Fundamentals

Learning rules and guidelines regarding materials, color concepts and techniques provides you with a foundation for making art. Once this foundation has been established, an understanding of painting fundamentals is essential to improve your skills and build your confidence. This chapter sheds light on such fundamentals, including what and where to paint and the elements of design and composition. A series of skill-building exercises will supply you with the study and practice needed to improve your paintings and to grow creatively.

Don't feel overwhelmed in the beginning, attempting to memorize every color and mixing chart or all the rules of design. Trying to hold a lot of art information in your head at one time is like trying to remember all the right moves of a golf swing! Just keep a few helpful sources of information nearby (like this book) for quick and easy reference. Soon everything will start clicking for you!

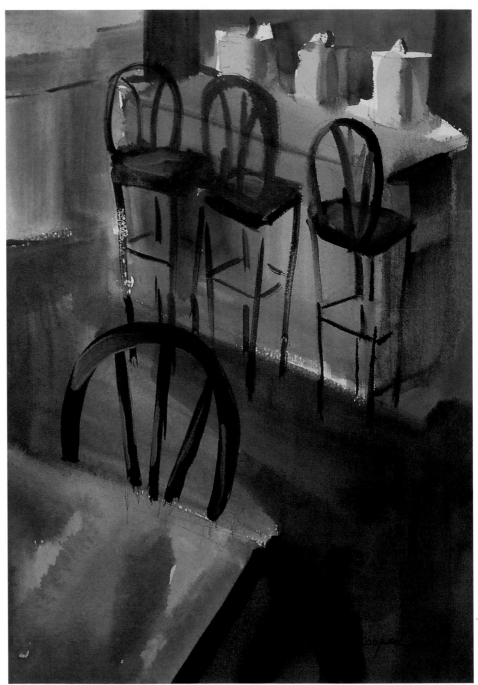

IRON HORSE COFFEE
13" x 9" (33cm x 23cm)

What to Paint

You may find yourself wondering "What should I paint?" This is the number-one question my students ask me. My answer is simply this: choose a subject that you connect with emotionally. Feeling passionate or enthusiastic about a subject translates into a more dynamic painting. Subject matter for your paintings can be found in many sources, including your own direct observations, magazines and photographs. Any idea that you may have is a potential subject. See which ones really grab you, and start sketching!

Observe Your Surroundings

One way to come up with ideas for your paintings is to observe your surroundings and make sketches of the scenes and objects that inspire you. A sketchbook is a very valuable tool for an artist. Observing and drawing on a regular basis will improve your painting skills. You become more aware of spatial relationships and design the more you sketch.

As you sketch, make a brief note of other sensory experiences besides the visual. When you are ready to develop your sketch into a painting, your notes on colors, temperature, smells, sounds and time of day will help the memory of the experience rush back to you.

Use Magazine Images

You can also use magazine images to draw inspiration for your compositions. Magazines serve as a great starting point for many beginners, as the images are readily available. When browsing through magazines, clip the pictures that you find interesting and keep them on file for future reference. Keep in mind, though,

that if you directly copy a photograph from a magazine with the intention to sell it, you will need to obtain the permission of the photographer or artist first.

QUICK TiP

USE YOUR IMAGINATION
You needn't always look around for inspiration. Imagination is one of the best sources for subject matter. Create, devise, invent and arrange any subject that you can imagine. The possibilities are limitless!

WORDS TO KNOW

ARTISTIC LICENSE Don't feel obligated to record a scene or subject exactly as it appears. When working from any source of inspiration, the artist is allowed to change any aspect of that subject to help improve his/her painting. For example, if green grass is in front of you but you don't feel that green would relate well compositionally, you have the license (ability/opportunity) to change the color.

Using a Viewfinder While Observing
When out exploring for interesting subjects to use in your paintings, take along a viewfinder (a small piece of matboard or cardboard with a small rectangle cut out of the middle) to help isolate a composition. Consider everything you see a potential subject for a painting!

Using Magazine Excerpts
These magazine excerpts were placed on poster board and then laminated. I use them as inspiration for color schemes, compositions and subjects. Keeping files of magazine images provides you with a wealth of creative ideas for your paintings!

Use Photographs

Many artists use photographs to get ideas for a composition. You can even combine images from several photos into a single creative composition, as demonstrated on this page. You can choose to include all of the elements found in the photograph or decide to focus on only a few objects. Using a viewfinder will help you crop your photos into tighter compositions. (Sticky notes make a convenient viewfinder. They can be applied directly to your photograph without harming it.)

Once you have an idea, begin planning a composition first in a sketch. As you begin to paint, follow the original plan as much as possible. Once you feel confident with your skills you can then make adjustments as you see fit. Remember, you don't have to be a slave to a sketch or photograph. Learn to edit, simplify and interpret to create your ideal composition.

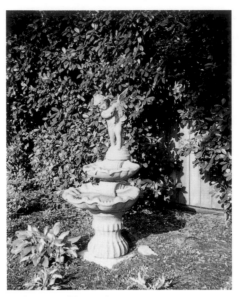

Reference Photo 1

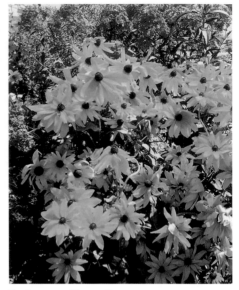

Reference Photo 2

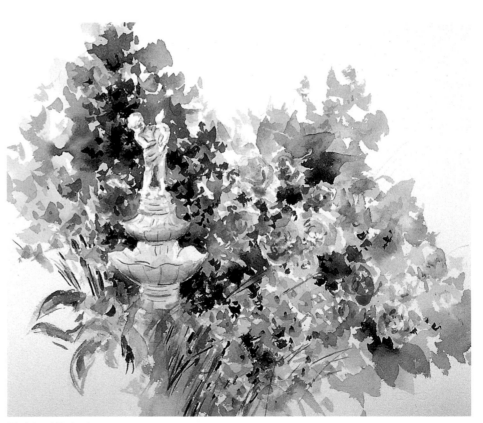

Finished Painting
With the sketch and photos as my inspiration, I started with my lightest colors and worked to make the painting progressively darker, using wet-on-dry, wet-in-wet and glazing techniques. Notice I exercised some artistic license in the finished piece by editing and simplifying.

MARGARET'S GARDEN
11" x 15" (28cm x 38cm)

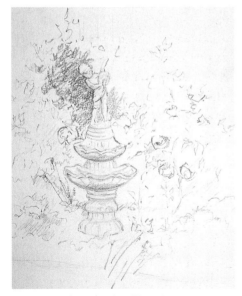

Making a Composite Sketch
Using my photos, I made a composite sketch and added a few values to indicate where I would place the dark colors. Working with a value sketch before beginning a new painting can be helpful.

Working From Reference Photos

The skill-building exercise shown here will detail how to use a photograph as inspiration for a painting. It will take you through the process, moving from a photo to a sketch to a finished painting.

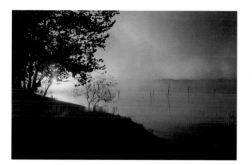

Reference Photo

I took this photo at my friends' home. The dazzling sunrise spilled over the hills and lake creating a moment of total peace. The fog rising off the water created quite an ethereal, other-worldly effect. Using this photo as inspiration, I tried to capture the essence of that scene in a painting.

WORDS TO KNOW

VALUE SKETCH A plan that helps the artist place light, mid and dark values in their paintings. These sketches are usually done with pencil or felt-tip pens.

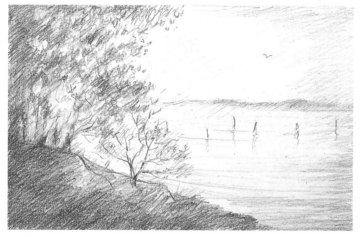

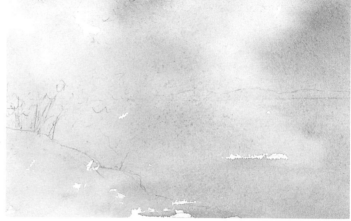

1 Sketch the Scene

Create a value sketch based on the reference photo. Arrange the lights, darks and midtones for a dramatic scene.

2 Apply Light Washes

Use Sour Lemon, Quinacridone Gold, Indian Yellow and Cadmium Orange in a wet-in-wet variegated wash over most of the paper using your no. 8 round. You can leave some white paper showing if you wish. Let this dry. Next, add Sky Blue and Cadmium Orange for the grays, using a lot of water to keep all of the edges soft. Let this dry.

MATERIALS

PAPER
140-lb. (300gsm) cold-pressed watercolor paper

BRUSHES
No. 8 round
1-inch (25mm) flat

WATERCOLORS
Cadmium Orange
Indian Yellow

Phthalo Blue
Quinacridone Gold
Quinacridone Sienna
Sky Blue
Sour Lemon
Ultramarine Blue

OTHER
HB pencil
Paper towels

QUICK TIP

TRANSFERRING YOUR SKETCH

There are many ways to transfer your sketch onto your water-color paper, such as overhead projectors, graphite paper and light boxes. These are fine, but one of the easiest ways is to tape your sketch to a window or glass door. Then tape your watercolor paper over that and begin tracing your work with an HB pencil.

Paint the hills after the initial sky wash is dry. First apply a watery mixture of Ultramarine Blue and Quinacridone Sienna using the wet-on-dry technique, then feather these lines out using more water like a graded wash. The horizon line is ambiguous due to the fog effect.

The water effect is created from the first wash of yellows. When this dries, apply a glaze of Sky Blue and Cadmium Orange and soften some of the edges. Next, add a glaze of Ultramarine Blue and Quinacridone Sienna as a darker layer in the upper and lower right corners. Allow your paper to dry.

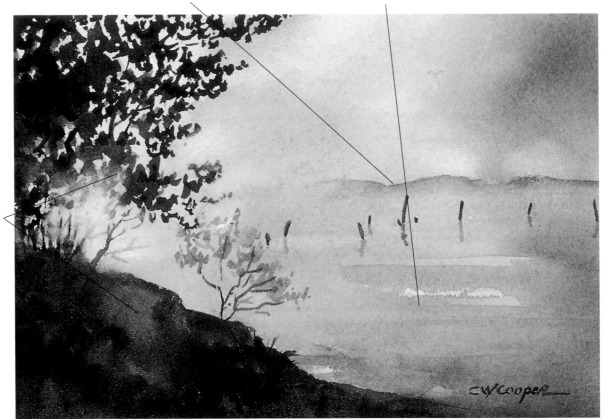

Create the trees and land, applying a very dry mixture of Ultramarine Blue, Quinacridone Sienna and Phthalo Blue. Drop some water and Ultramarine Blue into the ground area for a mottled effect. This helps define the rocky shore.

3 Add Darks and Final Details

Apply the darkest hues and values last using your no. 8 round. After they are dry, create the glowing sun streaking through the trees by lifting out the dark tree color with a corner of a damp 1-inch (25mm) flat, then blotting with a paper towel.

BARBARA'S WORLD
5" x 7" (13cm x 18cm)

WORDS TO KNOW

HORIZON LINE The horizon line is the imaginary line where the earth appears to meet the sky. It is also considered eye level. In design, placing your horizon line above or below the midpoint of your paper avoids cutting your painting in half visually.

QUICK TIP

SIGN YOUR ARTWORK

Signing artwork is a very personal thing. I prefer to sign my work in a color that was used in the painting—most often one of the darker colors. I use my round brush that comes to a good point and sign where I think it will help balance the painting.

Where to Paint

Now that you are aware of how to get ideas for paintings, you have to decide where you would like to paint. Whether you are painting indoors or outdoors, each situation has its benefits and challenges. Several factors will always influence your decision such as general preference, subject matter/source of inspiration, weather, time of day, and so on.

Painting Inside

Painting indoors can include painting in your home or studio, at a class or workshop or on location (indoors). Good lighting is mandatory when working indoors. Even if the room has access to natural lighting, you will need additional indoor lighting with color-balanced bulbs for accuracy. A still life is a good example of subject matter that you can easily paint indoors. Setting up your own still life with just a few simple objects is easy and fun. As a beginner, keep your still life rather simple at first, avoiding big elaborate arrangements.

Painting Outside

Painting outside on location is fun but presents its own set of challenges. You will need to pack up your supplies, a stool and some bottled water for both you and your painting. You can use an inverted medium-sized cardboard box for a painting table, and carry your supplies in it to and from your location.

One of the first challenges you might notice is the constant change of lighting outdoors. As a result, the *plein air* painter must work quickly. The next challenge is the overwhelming visual information that surrounds you. Use a viewfinder to help you isolate a good composition and avoid any distracting visual information.

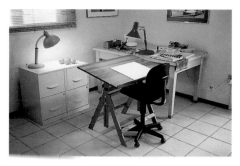

Painting in the Studio
This is my studio with a still-life arrangement in front of my art table. I placed a lamp over the fruit for a strong light source to create strong lights and darks. My paints, water and brushes are all on the right since I am right-handed.

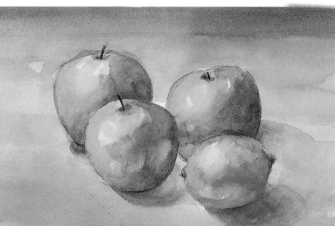

Still Life with Apples and a Lemon
I added dark values to create some drama in this otherwise simple still life. I darkened the background rather than leaving it white and I also gave the tabletop some color (artistic license!).

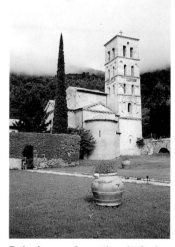

Painting on Location in Italy
Painting on location in Italy was a dream. This beautiful location was at San Pietro in Valle. The ancient monastery is a fantastic subject. Can you spot me in the snapshot?

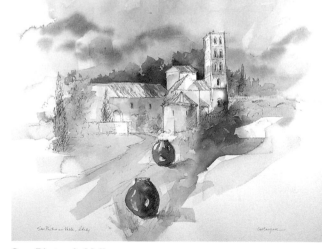

San Pietro in Valle
I loved creating this vignette of the beautiful Italian monastery. I sketched the scene using a fine waterproof black felt-tip pen and then added a series of glazes. I wanted to accentuate the wonderful giant terra-cotta pots that were out front.

Composition

Arranging your subject matter on your paper in a compelling composition is part of the equation of dynamic painting. The most interesting subject, painted with brilliant color and skillful technique, can quickly become average if your composition is weak. The next several pages discuss placement in conjunction with the basic elements and principles of design, all of which work together to form a solid composition. Consider the following as you design a composition:

✐ **Placing a horizon line:** Avoid cutting your composition in half horizontally. Place your horizon line either above or below your paper's midpoint.

✐ **Focal point:** This is a particular place of emphasis in your painting. Generally it is best to avoid placing your focal point in either the corners or center of your paper. The Rule of Thirds is one of the methods used for placement.

✐ **Positive and negative space:** Space is an element of design that involves being aware of your subject (the positive space) and the background or space around your subject (negative space). The two work in concert to unify a composition. Ignoring the background, then, will weaken your composition.

Avoid These Mistakes

The horizon line (the base of the mountains) cuts the composition in half. Also the strong pink color in the sky does not repeat anywhere else in the composition. Lastly, the sparse grass clumps are too isolated and do not relate well to each other, and the green color does not relate well with other colors in the composition.

Use the Rule of Thirds

The Rule of Thirds is a method of placing a focal point. It is one of your options when deciding placement of a center of interest. I chose the upper-right "dot" for my focal point.

Be Aware of Placement

Placing all of your subject matter on the bottom edge of your paper is weak compositionally. In this example, good placement creates both interesting positive and negative space. Lifting subject matter off of the bottom edge of the paper allows room for cast shadows as well.

Be Aware of Size

Enlarging your subject makes a bold statement and also breaks up the negative space into interesting shapes. Avoid the common compositional error of making the subject too small for the space allowed.

Design Basics

Now let's focus on the elements and principles of design. The five basic elements of design are line, color, shape, value and texture. When artists design a composition, their task is to express an idea in the most personally aesthetic way possible. Creating a strong composition involves working with these elements and making compelling relationships among them. This is achieved by employing the principles of design, or compositional devices that help organize the elements in a design. Some of the most popular basic principles of design include contrast, emphasis, dominance, balance, movement and repetition.

REPETITION
This principle is evident in the repeating tree and hill shapes.

VALUE, CONTRAST AND EMPHASIS
Value is the lightness or darkness of a color or tone. To achieve high contrast, place a light value next to a dark one. This is also a way to emphasize a subject or area.

FOCAL POINT AND BALANCE
There are two focal points in this sketch: the dark tree just to the left of center and the birds on the right. Both are contrasted against their surroundings. I placed the birds on the right side of the composition to balance the dark trees on the left.

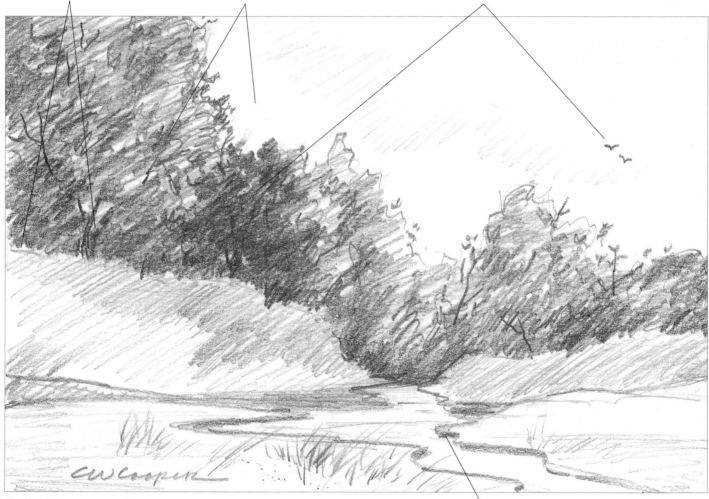

Design Elements and Principles at Work
In this value sketch I have employed many of the elements and principles of design to form a cohesive and unified composition. Notice the variety of values and the dominance of darks and midtones. I also varied the size and shape of the trees, hills, foreground and creek. The horizontal dominance of the composition is a restful direction. Unity is achieved by grouping a variety of values and having an interesting division of positive and negative space.

LINES AND MOVEMENT
Most of the lines in this drawing are organic (curved), which helps create a serene mood. The gently curving creek indicates movement as well.

Create Essential Forms

A form is a three-dimensional shape that has height, width and depth. In painting and drawing, it's your task to create the illusion of form by working with light and shadow.

Geometric forms provide a nice starting point when learning to work with your paints and subject matter. The forms are simplistic, but as you will see, they are the building blocks of many man-made and natural subjects. On the following pages you will practice making several essential shapes: spheres, cones, cubes and cylinders.

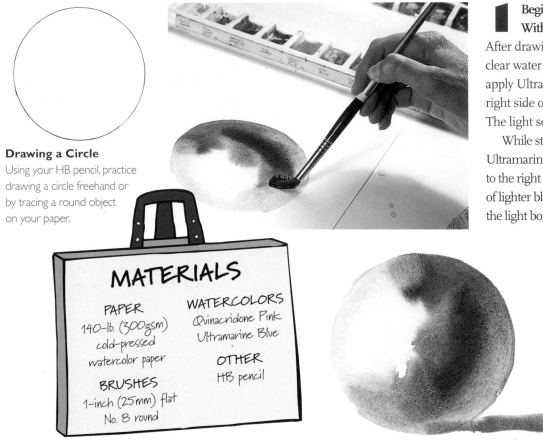

Drawing a Circle
Using your HB pencil, practice drawing a circle freehand or by tracing a round object on your paper.

MATERIALS

PAPER
140-lb. (300gsm)
cold-pressed
watercolor paper

BRUSHES
1-inch (25mm) flat
No. 8 round

WATERCOLORS
Quinacridone Pink
Ultramarine Blue

OTHER
HB pencil

1 Begin the Sphere and Create Volume With Color
After drawing a circle on your paper, apply clear water to it. Using your no. 8 round, apply Ultramarine Blue to the middle and right side of the sphere to create volume. The light source is coming from the left.

While still wet, apply a more intense Ultramarine Blue (less water in the mixture) to the right side of the sphere leaving a sliver of lighter blue on the far right to represent the light bounce.

2 Create a Cast Shadow
Drag a small amount of the blue toward the right at the base of the sphere for a cast shadow. This helps gives the illusion that the sphere is placed on a surface.

QUICK TIP

PAINT MIXING REMINDERS
- In the following exercises the plus (+) sign indicates to mix those specific paints together on your mixing surface.
- Spritz paint wells on your palette to moisten them.
- Dip your brush in water before going to your paint well.
- When an instruction says, for example, add Ultramarine Blue, always mix the blue with some water on your mixing surface before applying to your paper.
- A large amount of erasures on watercolor paper disturbs the tooth of the paper. If you are tentative with your drawing skills, lightly trace your original sketch onto your paper.

WORDS TO KNOW

SPHERE A sphere is a three-dimensional circle. Use a sphere as a starter for subjects such as heads, flowers, fruits, the sun, the moon and much more.

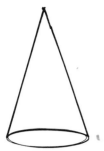

Drawing a Cone
An ellipse is the base of a cone. Avoid sharp, pointed corners, as an ellipse is an oval shape with rounded corners.

WORDS TO KNOW

CONE A cone is a three-dimensional triangle. It is the basis for subjects such as ice cream cones, flowers and brass musical instruments. It can be drawn with the tip up or down. An ellipse, or a circle seen in perspective, is a very important part of creating the illusion of a cone. Take a moment to practice drawing a series of ellipses on a piece of paper before you attempt to create a cone.

QUICK TiP

KEEP PERSPECTIVE IN MIND
When working with geometric forms, all curves and lines vary according to your perspective or **viewpoint** (above eye level, eye level, or below eye level).

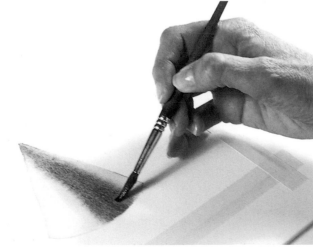

1 Begin the Cone
Draw a cone on your paper, starting with the ellipse-shaped base. Then draw an inverted V and connect these lines to the base, forming a cone. Add water to the cone and apply Ultramarine Blue to the middle in a somewhat vertical stroke using your no. 8 round. The light source will come from the left.

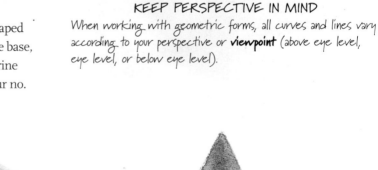

2 Create Volume
While the paper is still wet, continue to move the paint toward the right. Create volume by adding more Ultramarine Blue just to the right of center on the cone. This will give a darker, more intense look to that area. Leave the far right edge a bit lighter for the light bounce effect.

3 Add Final Details
While still wet apply more blue just to the right of center. Complete the form by adding some light blue to the left side of the cone leaving a white area just to the left of center. Drag a small cast shadow out from the base of the cone to help plant the cone.

Drawing a Cube

A cube can be drawn from many angles and views. One way is the straight-on view. Start with a square. Add three parallel lines extending from the cube. Then join the lines. The most important thing to remember when attempting to draw an accurate cube: all the lines directly across from each other are parallel.

1 Begin the Cube
Draw a cube from an overhead view with the light source coming from the right. With your 1-inch (25mm) flat, apply a light wash of Ultramarine Blue + Quinacridone Pink over it. Let dry.

2 Add Volume
The previous wash must be dry or the hard edges of the cube will diffuse into softness in this step. Apply a darker version of Ultramarine Blue to the left side of the cube, including cast shadows. Again, let your paper dry.

 WORDS TO KNOW

CUBE A cube is a three-dimensional square. The cube and the three-dimensional rectangle are the basis for such objects as buildings, columns, boxes, baskets, parts of the human form, books, trucks, and of course, ice cubes.

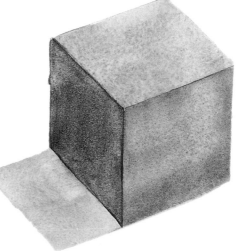

3 Add Final Details
Place a another light wash of Ultramarine Blue over the right side of the cube to help distinguish it from the top.

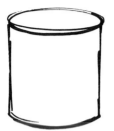

Drawing a Cylinder

Start with an ellipse. Draw two two vertical lines for the sides. Connect the two sides at the bottom of the cylinder with a curve that mimics the curve of the ellipse above. Some people make the mistake of drawing a flat line across the bottom when a curved one is needed.

CYLINDER The cylinder is a three-dimensional rectangle. It is the basis for a number of subjects such as a tube, rope, basket, barrel, column, vase, silo, stem, human neck, arm, leg, finger, stick, tree trunk, and so on. An ellipse plays a part in the making of a cylinder just as it did in the cone. If you are viewing your cylinder at eye level there will be a flat line and no curved line on the top or bottom.

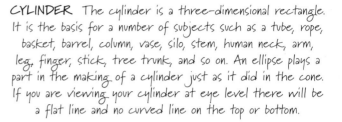

1 Begin the Cylinder

Draw a cylinder on your paper. In this instance, we are looking down slightly at the cylinder. Next, apply water to the cylinder with your no. 8 round, staying within the lines. While wet, place a vertical stroke of Ultramarine Blue down the center. The light source is coming from the left.

2 Add More Color

Add more Ultramarine Blue on the right side of the cylinder. This intensifies the shadow on the cylinder and creates a sense of volume. Leave the far right side a little lighter to show a light bounce off the table onto the cylinder.

3 Add Final Details

Add more water to move the paint around. Bring some of the light blue onto the top and down the left side of the cylinder to help give the cylinder more volume. Leave a strip of white on the left side just left of center to indicate the strongest area of light on the cylinder. Add a darker blue to the right side. Drag a small cast shadow at the base toward the right.

Combining Forms for a Painting

Most often when sketching it is easier to start with geometric forms as a base and then develop them into objects. This exercise is an example of how the basic forms are used as beginning shapes for a still life. The still life is then developed into a painting through a step-by-step progression of colors, values and textures.

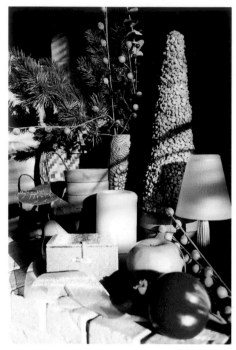

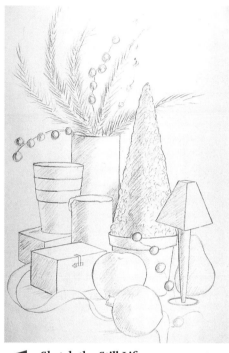

Reference Photo

Gather some items around your house and take a snapshot for reference. Here are some seasonal items on my hearth: small terra cotta pots, a ceramic vase full of greenery, a little topiary, a candle, gift boxes, ribbon, an apple, a lamp and a pomegranate. For dramatic purposes, I took the photo early in the morning with a strong light source streaming in the window from the morning sun.

1 Sketch the Still Life
Starting with geometric forms as a base when possible, sketch the scene adding any enhancements and changes that you wish.

2 Lay In a Light Wash
To establish some color quickly, place a light wash of Quinacridone Gold over the dry paper using your 1-inch (25mm) flat. Add some clear water to the paper to help move the paint around. Let this dry. To speed the drying process, use a hair dryer.

WORDS TO KNOW

LIGHT BOUNCE When observing a form, many times there will be a dark shadow side with a hint of light in it. This is caused by reflected light bouncing off another surface and hitting the object.

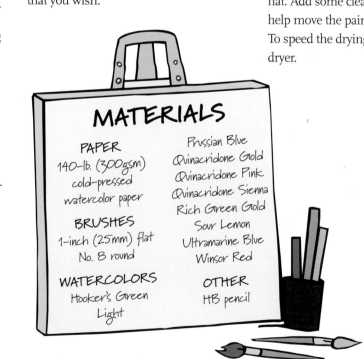

MATERIALS

PAPER
140-lb. (300gsm) cold-pressed watercolor paper

BRUSHES
1-inch (25mm) flat
No. 8 round

WATERCOLORS
Hooker's Green Light

Prussian Blue
Quinacridone Gold
Quinacridone Pink
Quinacridone Sienna
Rich Green Gold
Sour Lemon
Ultramarine Blue
Winsor Red

OTHER
HB pencil

3 Establish More Color

With your no. 8 round, apply Sour Lemon, Quinacridone Gold and Rich Green Gold to the greenery using the drybrush technique. Apply Quinacridone Sienna to the terra-cotta pots and greenery vase. Apply Quinacridone Gold + Rich Green Gold to the topiary. Place a light glaze of Sour Lemon + Hooker's Green Light on the background box. Apply Ultramarine Blue + Quinacridone Pink to the foreground box. For the lamp, apply a grayed Ultramarine Blue. For the pomegranate, apply layers of Quinacridone Pink then Windsor Red. Because of the initial wash in step 2, some of these colors will be applied to white paper and some will form a glaze over the yellow wash.

4 Add Glazes for Final Touches

Enhance shadows as well as textures. Using your no. 8 round, add Ultramarine Blue to create the shadows. To create the dark green in the greenery, use Hooker's Green Light and Prussian Blue. Each glaze is darker and richer in color. Each successive glaze should give the still life more voice and vibrancy. To do this, use more paint and less water in the glazes.

Landscapes

Now that you have learned the basics of watercolor painting and a few design tips, it is time to try painting some simple scenes. Each step-by-step project in this chapter explores the watercolor techniques discussed earlier in the book, providing you with more practice and enhancing your experience with watercolor. By applying the basics you have learned, you will be able to create simple landscape components such as trees, hills, fields, rocks, grasses and water. After you've completed these demonstrations and feel confident with your work, don't be afraid to create your own variations. Personal expression, individuality and imagination are the heart of creativity!

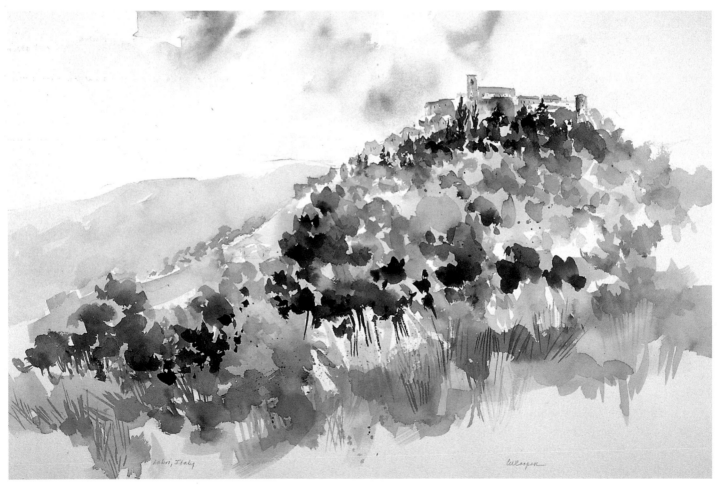

LABRO, ITALY
18" x 30" (46cm x 76cm)

Simple Landscape

Let's begin with a simple landscape consisting of sky, mountains and ground. After minimal sketching you will be ready to paint. The sky is painted with diagonal strokes; this is a nice contrast against the horizontal mountains and ground.

This project can be painted a section at a time. For example, let the sky dry while you work on the ground. Try not to over-correct by overworking areas with your brush. Allow a few blips to exist to keep your painting fresh. Try this project several times to build your confidence and skill. The more you work with your watercolors, the more you will begin to understand how much paint to apply and how much water to use. Getting the feeling of watercolor painting just takes practice.

MATERIALS

PAPER
140-lb (300gsm)
cold-pressed
watercolor paper

BRUSHES
No. 8 round
1-inch (25mm) flat

WATERCOLORS
Prussian Blue
Quinacridone Gold
Quinacridone Sienna
Ultramarine Blue

OTHER
HB pencil
Paper towels

1 Sketch Mountains
Using an HB pencil, lightly draw the mountains on the paper. Light pencil lines are acceptable on a watercolor painting. (This drawing has been enhanced with marker so that you can see it clearly.) When drawing the mountains do not begin your mountain line at the base of the horizon line. By starting it above the horizon line you give the illusion that the mountains continue.

2 Create Sky and Ground
With your 1-inch (25mm) flat, add water in diagonal strokes to the sky area. While wet, streak in some Quinacridone Gold, leaving some white paper showing. Create a variegated wash by adding Quinacridone Sienna and Ultramarine Blue to the sky. Tilt the paper various directions to create cloud effects.

Using the same brush, add water in horizontal strokes to the ground. While wet, streak in Quinacridone Gold, Quinacridone Sienna and a mixture of Quinacridone Sienna + Ultramarine Blue. Lift the bottom of your support board and tilt your paper towards the top so that the darker colors create the effect of grass. Allow your paper to dry.

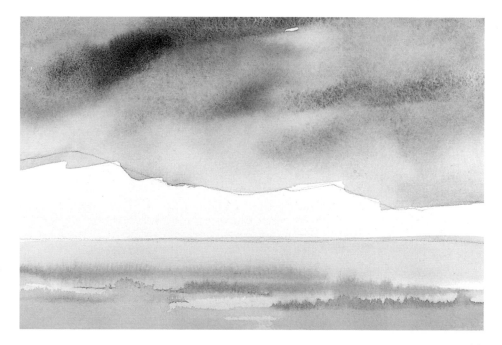

3 Paint the Mountains

Create a mixture of Ultramarine Blue + Quinacridone Sienna. The drier the mix the darker the color will be, while adding more water will make it lighter. Load your no. 8 round with the mixture. Remember, use the side of your brush when loading it with a mixture of paint and water. Paint the mountains starting at one edge and moving across your paper. Keep the edge wet and moving to avoid odd dry lines from appearing on the mountains. If you have to add more water, don't worry about the inconsistency in value—it will add interest to the mountains.

4 Add Trees at the Base of the Mountains

While the mountain is still damp, use your no. 8 round to drop in a rather dry mixture of Ultramarine Blue + Quinacridone Sienna + Prussian Blue for the trees at the base of the mountains. By dropping the dry tree mixture on the damp mountains, the trees will fuzz out slightly. Learning to control the water is a skill that will come with time. If your trees go wild, you have too much water in the tree mixture. If your trees do not spread at all (which is okay!), the mountains are too dry. When the trees are finished, allow the painting to dry before adding details.

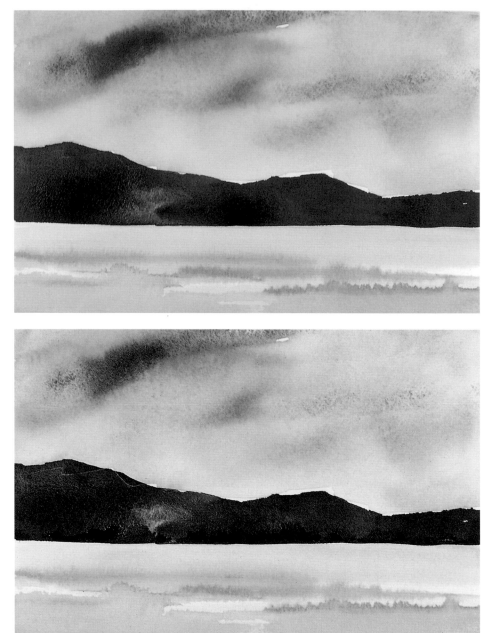

5 Add Grasses and Splatters

With your no. 8 round, wisp in some grasses in the foreground using a drybrush technique. Use Quinacridone Sienna and Quinacridone Sienna + Ultramarine Blue for the grasses.

Next, add a few splatters to the ground using any dark mixture. Cover the top of your painting with a paper towel or piece of paper to protect the sky from unwanted splatters. Then load your no. 8 round with Quinacridone Sienna + Ultramarine Blue. The drier your brush, the smaller the splatters. Gently tap your brush against a pencil to release the splatters, changing direction to avoid splatters all going in one direction. You can also splatter with different colors, creating another layer of texture, variety and interest in your painting.

6 Add Final Touches

Using a darker mixture of Ultramarine Blue + Quinacridone Sienna and your no. 8 round, place a few incidental birds in the sky. The birds can be simple checkmarks. Keep them small to retain the vastness of the subject. Painting birds is fun, but try not to get too carried away with them. Your painting can quickly turn into something out of a Hitchcock movie!

QUIET BEAUTY
8" x 11" (20cm x 28cm)

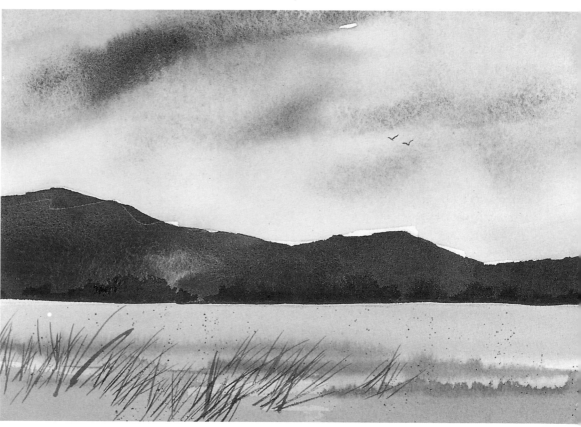

Reflections and Shadows

This demonstration concentrates on learning to work with reflections in water. Reflections are mirror images of the objects on or near the shoreline. Reflections are different from cast shadows, which are caused by a blocked light source. When painting a landscape on location, cast shadows change with the position of the sun. Reflections, on the other hand, are caused by the travel of light from the object to the water. From there the light bounces off of the water and travels to our eyes. When painting reflections in watercolor, mirror the subject loosely in the water. The finishing details of the reflected objects should be mirrored as well but appear softened. This project moves quickly from step to step, so read through the steps first.

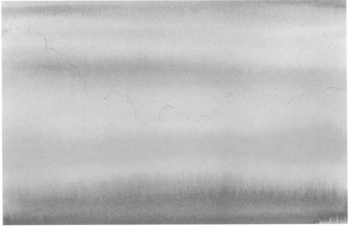

1 Draw Horizon and Trees, Apply Yellows

Using your HB pencil, draw the horizon line. Be careful not to visually cut your paper in half horizontally; go slightly above or below the midpoint. Also draw the tree line. Avoid making the trees all one size or your painting will lack interest. Then wet the entire surface of the paper using your 1-inch (25mm) flat. Mix Quinacridone Gold + Sour Lemon, applying this yellow paint mixture horizontally to the middle of your paper to establish the base color of the sky. While this step is still wet, quickly move on to step 2.

2 Add Pink

Continue developing the sky color. Use your 1-inch (25mm) flat to place Quinacridone Pink above and below the yellow in the sky, allowing them to mix on the paper. This graded wash is lighter in the center and gets darker on top and bottom. Tilt your paper from top to bottom to help blend the colors. Let your paper dry.

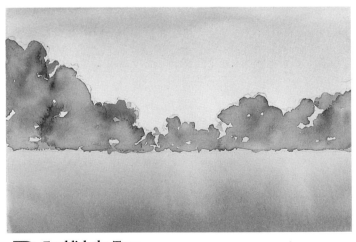

3 Establish the Trees

With your no. 8 round, place water on the trees, leaving some small dry patches. Drop in Quinacridone Pink then Rich Green Gold using the wet-in-wet technique. Allow some pinks and greens to mix. While your paper is wet, quickly move on to the next step.

MATERIALS

PAPER
140-lb. (300gsm) cold-pressed watercolor paper

BRUSHES
No. 8 round
1-inch (25mm) flat

WATERCOLORS
Quinacridone Gold
Quinacridone Pink
Rich Green Gold
Sour Lemon
True Green

OTHER
HB pencil

4 Place Darker Pinks on Trees

While the trees are still wet, randomly apply a few strokes of Quinacridone Pink to the trees to begin defining the foliage. Let your paper dry.

5 Continue Development of Foliage

Using your no. 8 round on dry paper, brush a small amount of True Green into some of the pink areas, allowing some of the first glaze to show through. Soften some of the edges with water to avoid a dotted look. Leave several edges distinct to give a texture to the leaves. Let this dry.

Using your no. 8 round apply Quinacridone Pink + Rich Green Gold + True Green to add more darkness to the foliage. Soften edges with water.

6 Create Reflections and Add Final Details

To give the painting detail, place tree branches in the trees and birds in the sky using a dry mixture of True Green + Quinacridone Pink. For the reflections in the lake, use your no.8 round on dry paper. Apply clean water to the lake, mirroring the shape of the trees somewhat. Next, drop in colors that you have used throughout the trees: Quinacridone Pink, Rich Green Gold and True Green. Allow your paper to dry.

Suggest some branches reflected in the water by painting them with the dry mixture used for branches earlier. Soften the reflected branches with clean water if necessary.

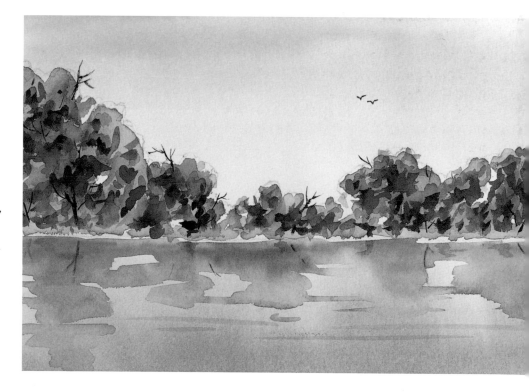

TREES AND WATER
8" x 11" (20cm x28cm)

Basic Foliage

As you can imagine, there are many ways to represent deciduous trees (trees with foliage) and coniferous trees (trees with cones, such as evergreens). In the previous demonstration, the foliage took on an autumnal look with a mass grouping of deciduous trees. Now practice creating some individual trees, both coniferous and deciduous, with the projects on the following pages. Avoid perfect symmetry as you paint either type of tree.

MATERIALS

PAPER
140-lb (300gsm) cold-pressed watercolor paper

BRUSHES
No. 8 round

WATERCOLORS
Phthalo Blue
Prussian Blue
Quinacridone Gold
Quinacridone Sienna
Sour Lemon
Winsor Blue

1 Start at the Top for a Coniferous Tree

To begin this coniferous tree, mix Phthalo Blue + Quinacridone Gold + Quinacridone Sienna with very little water. Using your no. 8 round, start with a vertical line and begin working your brush tip back and forth. The line is a guide for the center of the tree.

2 Continue Development

While Step 1 is still wet continue to widen the tree, obscuring the vertical line you painted. When you get to the base of the tree, immediately create the ground and grass using the same colors with more water added. This will help bridge the trees and the ground.

1 Underpaint Foliage

On dry paper, apply Sour Lemon in upward strokes using the side of the brush rather than the tip. Be careful not to make a perfect circle or triangle with the foliage. No lollipop trees!

2 Add a Mid-Green Glaze

Place strokes of Sour Lemon + Winsor Blue over the yellow in a random pattern. Group some of your strokes to avoid a scatter-shot look. Use water to soften some edges. The purpose is to lay a mid-green color over the yellow with some of the yellow still showing through in places. Winsor Blue is a staining color, so only a small amount is needed in your mixture.

3 Glaze on Dark Greens

Add more Winsor Blue to the mid-green mixture to create a darker blue-green. Remember, to get a darker mixture, avoid using a lot of water. Apply the dark green to the foliage to help create a shadow effect. Soften some edges with water. Let this dry.

Mix Quinacridone Gold + Quinacridone Sienna + Winsor Blue + Sour Lemon to create a dark green. Apply to the foliage for a dramatic shadow effect in the tree boughs. Soften some edges with water.

4 Finish With Trunk and Grass

Mix Quinacridone Sienna + Winsor Blue to create a dark brown. Weave the trunk through the foliage and extend a few branches. Add some water to the greens on your mixing surface to create a light green. Use this color to create a grass effect with a few squiggles, then some upward strokes for blades of grass.

Create Depth With Rocks and Trees

Now that you have had some practice painting individual trees, let's put one in a scene. This composition offers depth and texture. One way to create depth with subjects is to overlap them. Here the rocks overlap the trees, pushing them back into space. The rocks also overlap each other for another layer of depth. Finally, the grass in the foreground partially overlaps the rocks. Texture is created in this demonstration with the glazing and drybrush techniques.

MATERIALS

PAPER
140-lb. (300gsm)
cold-pressed
watercolor paper

WATERCOLORS
Quinacridone Gold
Quinacridone Sienna
Winsor Blue

BRUSHES
No. 8 round

OTHER
HB pencil

QUICK TIP

PAINTING SHADOWS

Shading is the darkness on the side of an object that is away from the light source. Placing shadows or shading on objects assists in the illusion of volume (depth). Artists typically use a darker value of the color of the object to create the shading, but any darker value will work. Darken with blues, browns, violets and so on. Think beyond gray for more expressiveness.

A cast shadow is formed when an object is blocking the light from reaching a surface. In painting, the cast shadow is generally darker near the base of the object and gets progressively lighter and more blurred the farther it extends. This can be achieved in watercolor by adding more water. Again, think creatively with color when working with cast shadows. Drop in a spot of warmth in a cool shadow for a subtle variation.

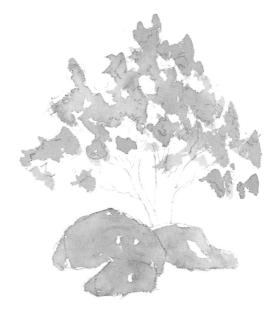

1 Lay In a Foundation
Using an HB pencil, lightly sketch the trees and rocks on a piece of watercolor paper. On dry paper, apply Quinacridone Gold to the foliage, using some water to help move the color. Leave some white paper showing through.

Next, apply Quinacridone Gold to the rocks. While damp, drop some water on the rocks to create texture.

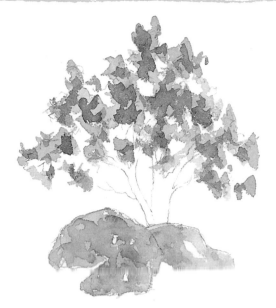

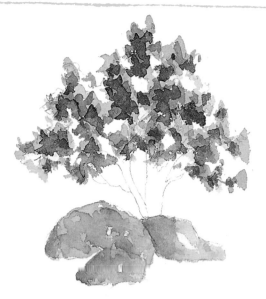

2 Add Depth to the Foliage
Add Quinacridone Gold + Winsor Blue randomly to the foliage, being careful not to cover up all the yellow. Add Quinacridone Sienna to the rocks. Soften a few edges with water.

3 Define Foliage and Add Shadows to Rocks
Apply strokes of Quinacridone Gold + Winsor Blue for the darkest green on the foliage. Apply a glaze of Winsor Blue on the left side of the rocks to create shadows, immediately softening the edges with water. Let this dry.

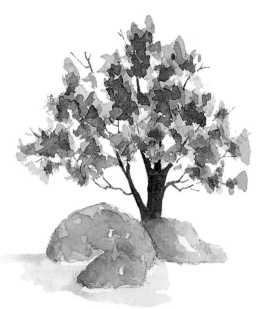

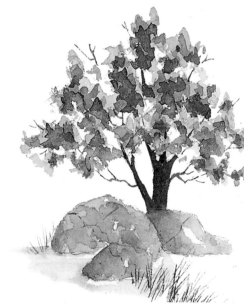

4 Create Trunk, Ground and Cast Shadows
Weave the tree trunks throughout the foliage using Quinacridone Sienna + Winsor Blue. Let this dry.

Using a watery mixture of Quinacridone Gold + Winsor Blue, create a suggestion of ground. Use the side of your brush to create horizontal strokes. While wet, drop in a bit of Winsor Blue for the cast shadows on the left. Let this dry.

5 Add Final Touches
Mix Quinacridone Sienna + Winsor Blue using very little water. Create fine lines and cracks in the rocks with this mixture. Using any green mixture, wisp in some grass on the ground using the drybrush technique. Allow your paper to dry.

Next, wisp in some darker grass using Winsor Blue. A variety of grass colors creates texture and interest. Let this dry.

Finally, add a few small splatters of Quinacridone Sienna on the rocks for another layer of texture.

ROCKS AND TREES
7" x 8" (18cm x 20cm)

Mysterious Forest

This composition works with strong lights and darks. Through a series of overlapping glazes, you will create a mysterious mood in this painting, which has a dominance of cool, dark colors. The creek in the foreground can be thought of as a path as well.

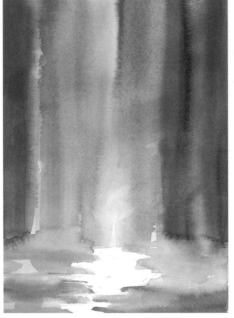

1 Draw Creek and Apply Yellows

Lightly draw the creek with your pencil. Using your 1-inch (25mm) flat, place water all over the paper except in the area reserved for the creek. Next place Quinacridone Gold, Indian Yellow and Sour Lemon on the wet paper allowing them to mix. Tilt your paper back and forth to encourage mixing. Let your paper dry.

2 Establish the Ground and Trees

Avoiding the creek again, place clean water on the ground using your flat brush. Next, apply some horizontal strokes of Ultramarine Blue on the moistened paper. While ground is still wet, add Ultramarine Blue in an upward vertical stroke over the dry yellow background. Immediately soften the stroke with clear water in an upward vertical stroke. This creates the illusion of soft distant tree trunks. Continue this until you have an interesting assortment of trees. Be careful not to line your trees up like soldiers; vary their width and the distance between them to avoid a repetitive composition. Let your paper dry.

3 Add Deciduous Trees

On dry paper, place a few leafless deciduous trees in the composition using Ultramarine Blue + Quinacridone Violet and your no. 8 round. Soften the base of the trees on the horizon line with water to help connect the trees to the earth. Spread the violet mixture onto the ground area pulling a bit of the color over the creek this time. Let your paper dry.

MATERIALS

PAPER
140-lb. (300gsm) cold-pressed watercolor paper

BRUSHES
No. 8 round
1-inch (25mm) flat

WATERCOLORS
Indian Yellow
Prussian Blue

Quinacridone Gold
Quinacridone Sienna
Quinacridone Violet
Sour Lemon
Ultramarine Blue

OTHER
HB pencil
Paper towels

QUICK TIP

DRYING YOUR PAINTINGS
Consider using a hair dryer to speed up the drying process.

4 Add a Dark Layer

Using your 1-inch (25mm) flat, darken the left and right edges of the painting with a mixture of Ultramarine Blue + Quinacridone Violet. Glaze each side, softening the edges with clear water. The darkened areas will lead the viewer's eye into the center of the painting.

Paint the coniferous trees with a no. 8 round and Ultramarine Blue + Quinacridone Violet + Prussian Blue. Paint this mixture onto the ground area as well. Add water to this mixture and paint in the paler, distant trees. Add a few darker strokes to the ground area using a mixture of Ultramarine Blue + Quinacridone Violet.

5 Add Final Touches

Paint several more leafless deciduous trees using a dark mixture of Quinacridone Violet + Quinacridone Sienna. Next, with a dark mixture of Ultramarine Blue + Quinacridone Violet, place some strokes in the lower right foreground. Allow your paper to dry.

To create the moon, use the corner of a damp 1-inch (25mm) flat to lift out the paint in a circular motion. Dab the area with a paper towel to absorb more paint.

AFTER THE RAIN
11 x 7 ½" (28cm x 20cm)

DEMONSTRATION
Seascape

This seascape involves a dramatic sky and sea. I chose this subject because it gives you another opportunity to work with water—this time on a grand scale. Working with low-intensity colors, you will create the illusion of a gray day at the beach. The spray hitting the rocks is a wonderful splattered texture.

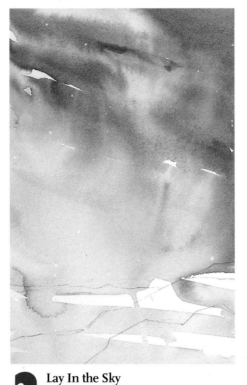

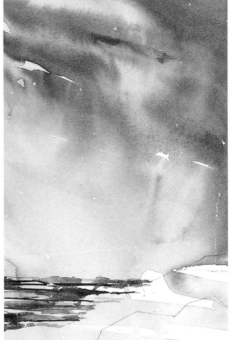

1 Create a Composition
Compositionally, this painting focuses on the sky, so place the horizon line fairly low on the paper. When lightly drawing the rocks in the foreground, allow the top right of the rocks to rise above the horizon line created by the water. This will help pull the rocks forward in the painting and give more visual interest to the composition.

2 Lay In the Sky
Place water diagonally in the sky using your 1-inch (25mm) flat. Leave a small amount of dry paper if you wish. Next, layer Ultramarine Blue, Ultramarine Blue + Quinacridone Sienna, and Ultramarine Blue + Quinacridone Sienna + Prussian Blue. Place a few strokes of the various gray mixtures over the rocks as well. Tilt the paper vertically, making the water and color run toward the bottom of the paper.

3 Create the Sea
Paint light gray horizontal strokes to indicate waves in the water using your no. 8 round. Use the same colors that were used in the sky to create the color of the sea. Add some Cobalt Teal Blue for interest. Allow your paper to dry.

Add drier, darker versions of the colors for a value change. Paint horizontal lines over the lighter grays to indicate shadows in the water. If the lines look too perfect, soften them with water. Let this dry.

MATERIALS

PAPER
140-lb. (300gsm) cold-pressed watercolor paper

BRUSHES
No. 8 round
1-inch (25mm) flat

WATERCOLORS
Cobalt Teal Blue
Prussian Blue
Quinacridone Sienna
Ultramarine Blue
White gouache

OTHER
HB pencil

QUICK TIP

RECLAIM YOUR PAINTING
On a project like this, if there is an area that you dislike, cover it with white gouache splatters! It works wonders!

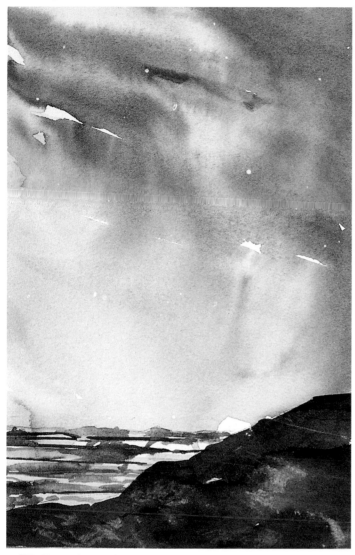

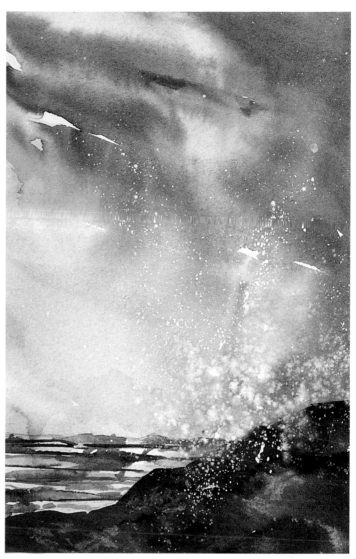

4 Form the Rocks

Apply Prussian Blue + Quinacridone Sienna followed by Ultramarine Blue to the rocks with a small amount of water using your no. 8 round. While damp, press a crumpled tissue over the rocks and then quickly lift it off. This will produce an immediate texture on the rocks. Let this dry.

5 Create Sea Spray and Add Final Details

If the area in the sky just above the rocks is too light, the sea spray won't be defined in your painting. Using your no. 8 round, darken this area of the sky by wetting the paper in that area only. Next, place Ultramarine Blue + Quinacridone Sienna just above the rocks. Lose the edge of the darker color by applying clear water to fade the edges into the sky. If you wish to vary the edge of the rock against the sky, soften a small portion of the top of the rock on the right with a damp 1-inch (25mm) flat. While this area is damp, use your no. 8 round to splatter white gouache where the rock meets the sky. Create splatters in the sky as well. The white gouache will mix with the water on the paper and form soft splatters. Let this dry.

After the first round of splatter has dried, use your no. 8 round to splatter more white gouache in the same areas, as well as in the sky. This creates a variety of sea spray effects.

GALVESTON
11" x 7 ½" (28cm x 20cm)

Flowers

Flowers make excellent subjects
for a painting. Their natural shapes,
color and beauty have inspired count-
less artists throughout the ages. This
chapter explores a variety of flowers in
different settings, ranging from simple
to complex. In each demonstration
you will discover that layering paint
using different techniques provides
your paintings with rich texture, color
and depth.

Just as before, I encourage you to
observe the composition in each project.
After working with the composition
and the steps provided, you may want
to repeat the project, creating your own
variation. Try using one or more of
these alterations to design your own
composition: enlarge or diminish the
subject, change the subject's placement
or vary the colors and values used. The
more you practice creating your own
compositions, the more confidence
and skill you will gain.

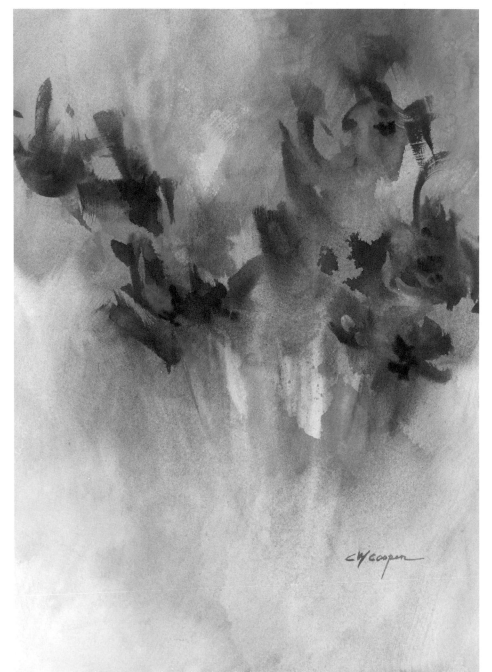

BLUE IRISES
14" x 10" (36cm x 25cm)

Simple Flowers

These simple flowers provide a good starting point and illustrate the ease of creating flowers by dropping color on wet paper. The dark contrasting background helps to emphasize the flowers. Alternating between hard and soft edges on the flowers adds interest and sensitivity to the painting. The various edges also integrate the flowers with their background, allowing the painting to become a unified whole.

1 Draw and Establish Base Color

With your HB pencil, draw two simple flowers. Apply water randomly over the sketched flowers. On the left flower apply Sour Lemon, Indian Yellow and Quinacridone Gold. Mix these colors on the paper just a bit. On the right flower, drop in Quinacridone Pink. While wet, drop in Indian Yellow. Allow the pink flower to bridge over and touch the yellow flower. While both flowers are wet, create their dark centers by dropping in a fairly dry mixture of Ultramarine Blue + Quinacridone Sienna. Let this dry.

2 Block In the Background

Saturate the background with water, and drop in a variety of greens varied with Quinacridone Gold: Skip's Green, Winsor Green and Hooker's Green Light. For darker green, mix Ultramarine Blue + Prussian Blue + Quinacridone Gold. To avoid the cut-out look, soften some of the edges with clean water where the background color meets the flower petals. Pull a small amount of green over the petals in a few places to tie the flowers to the background. Let this dry.

3 Glaze and Add Details

Glaze a small amount of Quinacridone Pink over the pink flower leaving some base color showing. This layered look adds interest and depth to the petals. Do the same with the yellow flower by glazing a small amount of Quinacridone Gold over it. Add a few dark spots on the centers of the flowers by mixing Ultramarine Blue + Quinacridone Sienna with very little water.

FOR THE BEAUTY OF THE EARTH
5" x 7" (13cm x 18cm)

MATERIALS

PAPER
140-lb. (300gsm) cold-pressed watercolor paper

BRUSHES
No. 8 round

WATERCOLORS
Hooker's Green Light
Indian Yellow
Prussian Blue
Quinacridone Gold
Quinacridone Pink
Quinacridone Sienna
Skip's Green
Sour Lemon
Ultramarine Blue
Winsor Green

OTHER
HB pencil

Basic Flower Pots

This demonstration focuses on simple flowerpots as subjects. The technique emphasized is watercolor and felt-tip pen. This is a favorite technique of mine. I love the combination of drawing and watercolor. This project uses wet-in-wet and wet-on-dry techniques as well. Make the flowers as vibrant as you wish by continuing to drop in brilliant color while the paper is still wet and glistening.

MATERIALS

PAPER
140-lb. (300gsm)
cold-pressed
watercolor paper

BRUSHES
No. 8 round

WATERCOLORS
Hooker's Green Light

Quinacridone Pink
Quinacridone Sienna
Red Hot Momma
Rich Green Gold
Ultramarine Blue

OTHER
Waterproof black
felt-tip pen

1 Sketch the Pots
Using a black waterproof felt-tip pen, sketch the flowerpots onto the watercolor paper. Don't make a complete ellipse on the top of the pots. Leave a few open spaces so you can add the flowers later. If you are a bit leery of drawing with the pen, lightly sketch the pots in pencil first. Then go over those guidelines with the pen and erase any visible pencil marks.

2 Color the Flowers
Apply clear water to the flower areas leaving a bit of dry white paper. Drop in Quinacridone Pink and then Red Hot Momma using the wet-in-wet technique. Using the wet-on-dry technique, use a small amount of these colors to extend several flowers onto dry areas of the paper beyond the wet flowers. Remember: as long as the paper is glistening, you can keep dropping in color without getting odd dry lines (hard edges) or creating a bloom. Allow your paper to dry.

3 Paint the Pots and Cast Shadows
After your paper has dried, paint the flowerpots with Quinacridone Sienna leaving a few vertical streaks of white in the paper. While the color is still wet, drop in Ultramarine Blue on the right side of the pots. At the base of the pots, drag a small amount of the blue toward the right, creating cast shadows. Let this dry.

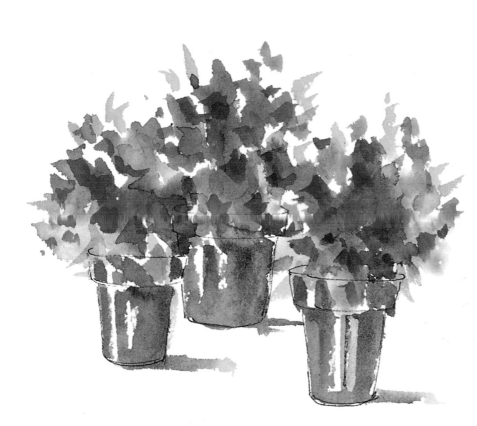

4 Create Leaves and Enhance Flowers

Using a small amount of water, wisp in some green leaves using Rich Green Gold and Hooker's Green Light. Soften some of the edges with clean water. Let this dry.

Enhance the flowers by adding a glaze of Quinacridone Pink + Red Hot Momma. Blend a few edges with water.

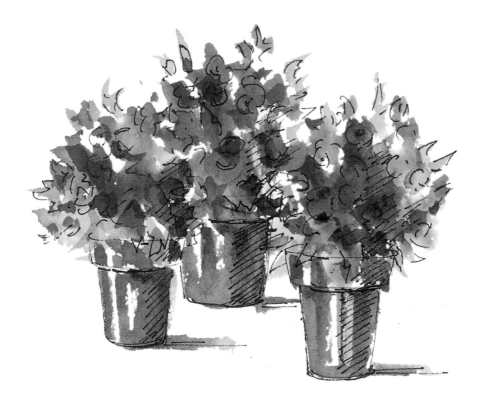

5 Add Final Details

Using your felt-tip pen, squiggle in a few shapes to outline some of the flowers and leaves. Also use the pen to create some shading (diagonal lines) on the pots and in the flowers.

WENDE'S BACK PORCH
6" x 7" (15cm x 18cm)

Flowers in a Landscape

This project is a change of formula from most of the step-by-steps you have done so far. Instead of starting with a sketch or any pencil guidelines, begin with water, paint and an idea of flowers in a field. With no sketch or outline to guide you, you can shape the composition as you go.

Your painting should have three components: background (sky), middle ground (distant green grass) and foreground (flowers). First concentrate on the sky and grass, applying water to these areas and then applying color. The two areas will slightly blend, creating a sense of unity. When working with the flowers, stay loose with your strokes. By dropping in colors on a wet surface, your field of flowers will appear quickly in a glorious burst of color. Glazing over the initial flowers will help to define them.

When painting a group of flowers in nature, avoid trying to paint each individual flower. This can make a painting appear tedious and boring. Think masses with a few singles. Vary the height and direction of the flowers and stems to keep them more natural-looking.

MATERIALS

PAPER
140-lb. (300gsm)
cold-pressed
watercolor paper

BRUSHES
No. 8 round

WATERCOLORS
Hooker's Green
Light
Indian Yellow
Prussian Blue
Quinacridone Gold
Quinacridone Pink
Quinacridone Sienna
Quinacridone Violet
Rich Green Gold
Skip's Green
Sky Blue
Sour Lemon
Ultramarine Blue
Winsor Red

1 Paint Sky and Ground
Without sketching the composition, wet the sky and middle ground areas. Drop in Sky Blue on the top of your paper then immediately, while it is still wet, apply Hooker's Green Light and Rich Green Gold. Wash a small amount of the green down the center of the paper toward the bottom edge using some clear water. Let your paper dry.

2 Create Flowers
Wet the area where the flowers will be. Immediately drop in Indian Yellow, Sour Lemon, Quinacridone Pink and Winsor Red with a medium amount of water in the brush each time. Be sure to clean your brush between each color application. The colors will blend slightly, but will also retain their own character in certain places. Place a few dabs of the same colors on the dry paper as well to indicate a few individual flowers. While the flowers are moist, suggest a few stems and grass blades using Skip's Green.

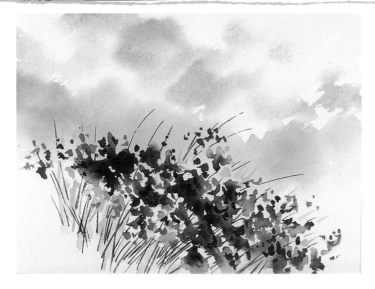

3 Enhance Flowers and Grass

On dry paper, add a few dabs of Indian Yellow, Quinacridone Pink and Winsor Red to the flowers. This glaze will help define more individual flower groups. Let this dry.

Wisp in a few more blades of grass and stems using Ultramarine Blue + Quinacridone Gold for the medium-value green, then Quinacridone Gold + Prussian Blue for the darker value. Weave some of the grass blades through the flowers and into the sky. This will help bridge foreground to background.

WILD FLOWERS
8" x 9" (20cm x 23cm)

4 Add Final Details

Mix Ultramarine Blue + Quinacridone Violet to create shadows in the flowers. Add some water to soften a few edges and avoid a dotted look. Use Ultramarine Blue + Quinacridone Gold with very little water to paint more stems.

Protect the sky with a scrap sheet of paper, and then splatter Quinacridone Pink on the flowers and Skip's Green on the stems and grass. Paint a few birds in the sky just right of center with Ultramarine Blue + Quinacridone Violet + Quinacridone Sienna.

WORDS TO KNOW

DOMINANT DIRECTION Notice how this composition has a dominant diagonal direction. If the sky, middle ground and flowers were in straight horizontal rows, the composition would not have as much energy or interest.

Sunflowers

This project focuses on colorful flowers set against a dark background. The dark background colors are used to shape the flowers. This is considered negative painting. The background of a painting is considered the negative space and the subject is the positive space. Painting negatively usually involves using darker paint in the background to help form positive shapes. The initial application of the flower colors can be loosely painted with no worries of an exact shape. The dark background colors will later shape and emphasize the flowers. Try to keep your style rather loose and expressive through this entire project.

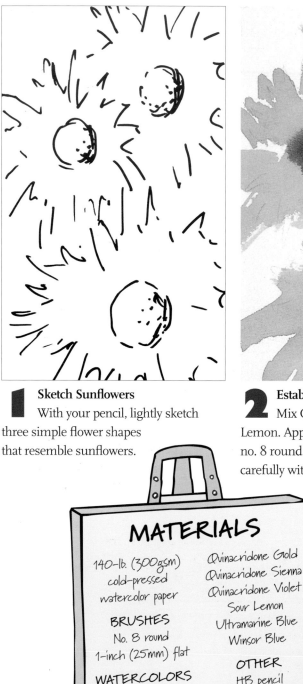

1 Sketch Sunflowers
With your pencil, lightly sketch three simple flower shapes that resemble sunflowers.

2 Establish Color on Flowers
Mix Quinacridone Gold + Sour Lemon. Apply this to dry paper using your no. 8 round. Don't worry about staying too carefully within the lines, as the dark background colors will shape the flowers later. Then, while the yellow color is still very wet, drop in Quinacridone Sienna into the center of each flower. Let this dry.

3 Paint the Background
Using your no. 8 round, create the background using various mixtures of Quinacridone Gold + Winsor Blue and Ultramarine Blue + Quinacridone Violet. For variety, alternate between the greens and violets. Shape the flowers with the darker mixtures. Do not outline each petal with the dark background colors. Rather, be selective and allow some white of the paper to show through for snap.

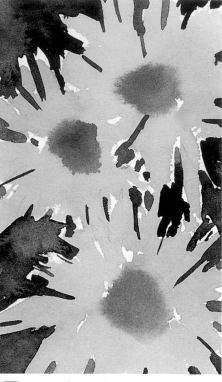

MATERIALS

140-lb. (300gsm)
cold-pressed
watercolor paper

BRUSHES
No. 8 round
1-inch (25mm) flat

WATERCOLORS
Prussian Blue

Quinacridone Gold
Quinacridone Sienna
Quinacridone Violet
Sour Lemon
Ultramarine Blue
Winsor Blue

OTHER
HB pencil

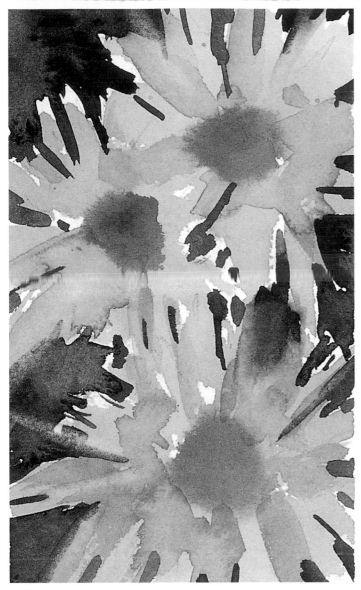

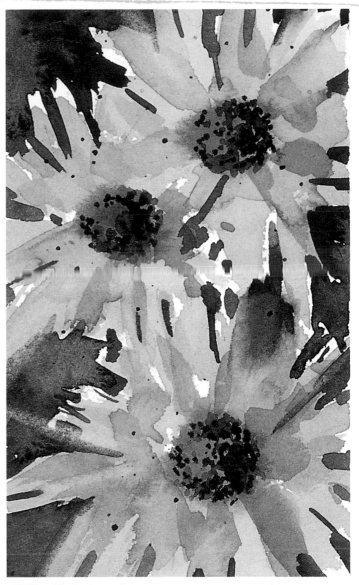

4 Enhance Values

Using your 1 inch (25mm) flat, add a glaze of Quinacridone Gold on the petals in a few places to create form. Soften a few edges with water by dragging a damp, clean flat brush over some petals, starting from the center and pulling out toward the tips. This will most likely lift some color, so restate both flower colors and background colors if needed.

5 Add Final Touches

For the center of the flowers, dot on a mixture of Ultramarine Blue + Quinacridone Sienna + Prussian Blue with your no. 8 round. To create a dark color, use a minimal amount of water in the mixture. Soften some of the dots with water. Let this dry.

Still using your no. 8 round, add a glaze of Quinacridone Sienna in just a few places on the flower petals. Allow your paper to dry once again.

Finally, add a few dark splatters using the Ultramarine Blue + Quinacridone Sienna + Prussian Blue mixture.

SUNFLOWERS FOR LINDA
6" x 4" (15cm x 10cm)

WORDS TO KNOW

NEGATIVE PAINTING This technique has nothing to with bad moods! It's painting around or behind a shape to help define it.

Paint a Flower Close-Up

The radiating petals and leaves of this flower give this composition drama. In this demonstration, you will work again with a light subject against a dark background; this contrast guarantees a good recipe for visual impact. Also, the combination of hard and soft edges give this painting character and interest. The limited color scheme is an automatic unifier in this painting. Notice that the center of the flower was positioned using the Rule of Thirds.

1 Sketch Image and Establish Base Color

Lightly draw the image on your paper. Mix Sour Lemon + Quinacridone Gold on your palette. While the paper is dry, use your 1-inch (25mm) flat to randomly place color on the petals and leaves and in the background. Leave some white paper showing. Place a few lines on the petals using the tip of brush. Be careful not to be too uniform with the lines. Let your paper dry.

2 Paint the Background

Wet the background using clear water and your no. 8 round. While wet, drop in Hooker's Green Light, Cobalt Teal Blue and Quinacridone Gold. Allow the colors to mix on the paper and then dry.

3 Intensify the Background

Mix Quinacridone Gold + Quinacridone Sienna + Prussian Blue with water. Create a few leaves with this mixture, using your no. 8 round. Let your paper dry again.

Add a touch more Prussian Blue + Quinacridone Sienna to create the darkest values in the background. Paint near the center of the flower, adding more water as it moves away from the center. Losing the edge like this allows the beautiful under-painting to show through in certain areas. Let this dry.

MATERIALS

PAPER
140-lb. (300gsm) cold-pressed watercolor paper

BRUSHES
No. 8 round
1-inch (25mm) flat

WATERCOLORS
Cobalt Teal Blue
Hooker's Green Light • Prussian Blue
Quinacridone Gold
Quinacridone Sienna
Sour Lemon

OTHER
HB pencil

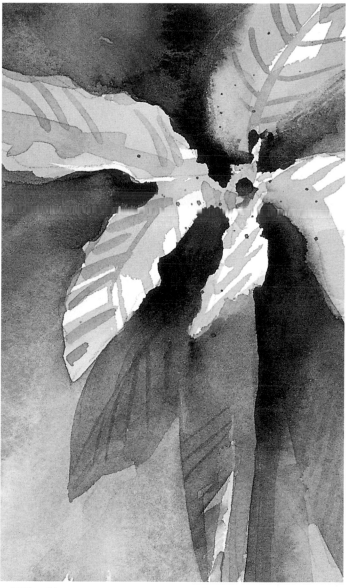

5 **Layer Additional Colors**
Using your no. 8 round, place some Quinacridone Gold on the flower petals in a loose pattern. Lift some color off the edges of the petals to soften them using a damp 1-inch (25mm) flat. Add Hooker's Green Light and Quinacridone Gold to the leaves and the background. Allow your paper to dry.

6 **Add Final Details**
If necessary, use your no. 8 round to restate darks. Do this by first adding water to the area you wish to darken and then adding Quinacridone Sienna + Prussian Blue. Add a few strokes of Hooker's Green Light + Quinacridone Gold to the leaves and more Cobalt Teal Blue to the background. Then, add a few more detail lines to the flower petals using Quinacridone Gold. Finally, create texture by splattering the center of flower with Hooker's Green Light + Quinacridone Gold using your no. 8 round.

FLOWER
6" x 4" (15cm x 10cm)

Still Life

A still life is an arrangement of inanimate objects for the purpose of painting or drawing. The study of still life is a time-honored tradition for artists, with its earliest beginnings dating back to the Renaissance. Today, still lifes remain popular subjects for paintings and drawings. This chapter will spotlight simple still life arrangements of various fruits and flowerpots, familiarizing you with this classic style.

After working with the projects in this chapter, set up your own still life (use apples, bottles, books, baskets, etc.) and practice working from the actual objects themselves. Viewing objects in three dimensions will help you learn about depth and shadows.

Whether working on the provided demonstrations or creating your own still lifes, notice the relationship between objects. For instance, observe spaces between objects and whether some objects overlap each other. When you begin painting, think about placement on the paper and avoid lining objects up at the bottom edge of your paper. Be creative!

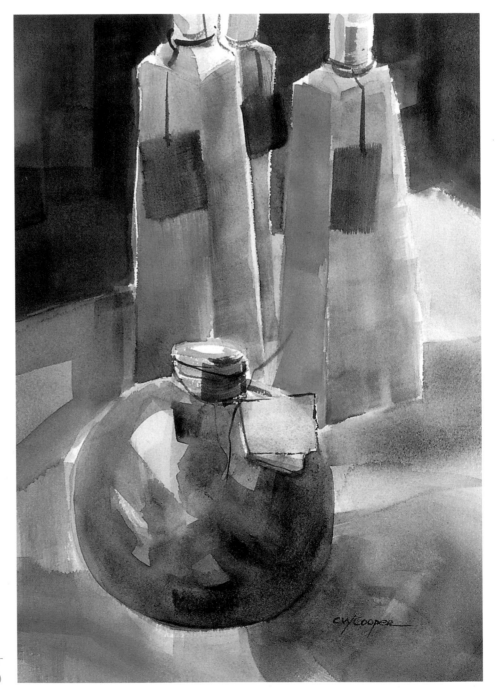

OLIVE OIL BOTTLES AT THE MARKET
15" x 11" (38cm x 28cm)

DEMONSTRATION
Figs

When I studied art at La Romita in Terni, Italy, my hosts prepared incredible feasts everyday! One day at lunch, I spotted these beautiful green figs heaped in a big woven basket. I placed a few of the figs on the table and did a quick sketch. They resemble pears, but they are figs. Aren't they a great shape?

MATERIALS

PAPER
140-lb. (300gsm)
cold-pressed
watercolor paper

BRUSHES
No. 8 round

WATERCOLORS
Lemon Yellow
Prussian Blue
Quinacridone Gold
Quinacridone Sienna
Quinacridone Violet
Rich Green Gold
Ultramarine Blue

OTHER
HB pencil

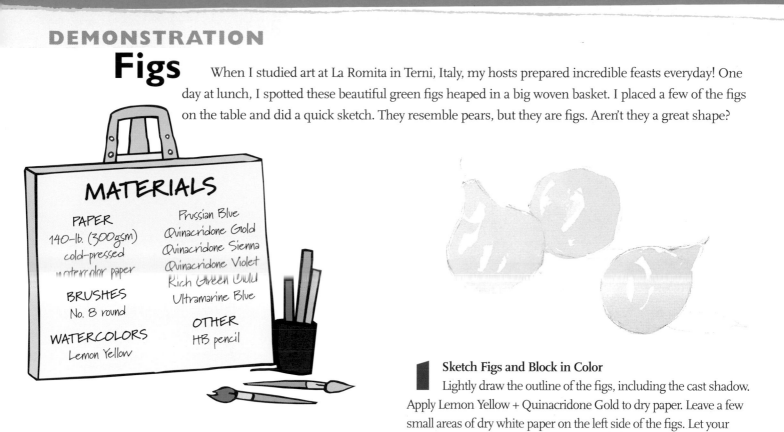

1 Sketch Figs and Block in Color
Lightly draw the outline of the figs, including the cast shadow. Apply Lemon Yellow + Quinacridone Gold to dry paper. Leave a few small areas of dry white paper on the left side of the figs. Let your paper dry.

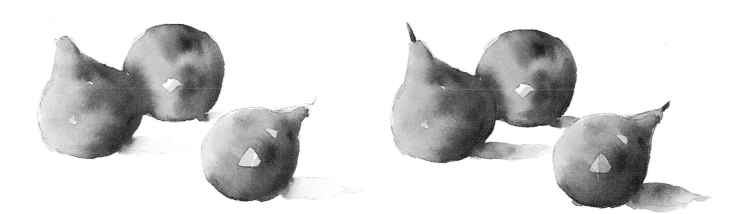

2 Create Depth and Cast Shadows
Lightly re-wet the surface of the figs. Use the wet-in-wet technique to drop in Rich Green Gold, then Prussian Blue + Rich Green Gold. While still wet, drop in a mixture of Prussian Blue + Quinacridone Sienna on the far right of the figs (the shadow side). While all of this is still wet, take your brush and drag some of the green mixture from the base of the fig and pull it toward the right. This makes a nice cast shadow that integrates well with the fig. Let this dry.

3 Add More Darks and Shadows
Place a small amount of water on the right side of the figs. Then place Prussian Blue + Rich Green Gold + Quinacridone Sienna on the wet side of the figs. Pull some of the paint color into the cast shadows. While the cast shadows are wet, drop in a touch of Ultramarine Blue + Quinacridone Violet. This cools the cast shadows and gives them a different look from the figs themselves. Again, let your paper dry. Paint the stems with a very dry mixture of Prussian Blue + Quinacridone Sienna.

FIGS FOR LUNCH
8" x 11" (20cm x 28cm)

DEMONSTRATION
Three Pots

Working with these simple flowerpots is fun. There are so many possibilities as to what you can create! Don't feel as though your painting has to match the reference photo exactly, simply use this picture as your guide or as a means of inspiration. Experiment with variations of size, color and placement. Think of the pots as angled cylinders, and be aware of the ellipses at the top and curves at the bottom of each.

MATERIALS

PAPER
140-lb. (300gsm)
cold-pressed
watercolor paper

BRUSHES
No. 8 round

WATERCOLORS
New Gamboge
Quinacridone Pink
Quinacridone Sienna
Ultramarine Blue

OTHER
HB pencil

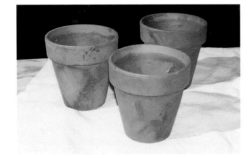

Reference Photo

1 Sketch Pots and Establish Base Color
Lightly draw the pots on your paper using your HB pencil. Avoid lining the pots up at the bottom edge of your paper. If the objects are lined up too meticulously, your painting will lack interest.

Place some water on the pots using your no. 8 round. Next apply New Gamboge and Quinacridone Sienna, allowing them to mix on the surface. Drag the Quinacridone Sienna to the right for the cast shadows. Let your paper dry.

QUICK TIP

LEAVE SOME WHITE
Sometimes leaving white spaces throughout a painting gives it sparkle or snap. Learning when and how much to leave is a personal choice. Here are a few tips to keep your whites sparkling.
- Paint around whites, leaving the white paper exposed.
- Protect whites by using masking material, which can be painted over and removed when the paint is dry.
- Scratch into the dry painted surface with a craft knife to reveal white paper.
- Apply white to a painted surface using white gouache.
- Lift paint with a damp, stiff bristle brush, then dab the surface with an absorbent paper towel.

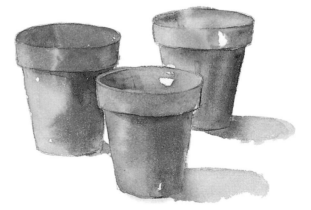

2 Add Final Shading and Details
Place a small amount of clean water on the inside left of the pots and on the outside right. Next, place Ultramarine Blue + Quinacridone Pink on those areas. Let this dry.

Finish up the pots with a rather dry mixture of Ultramarine Blue + Quinacridone Pink. Place a few outlines to help define the pots using Ultramarine Blue and Quinacridone Sienna.

DEMONSTRATION
Pears

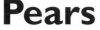

Pears have always been a popular subject for still life. Their wonderfully organic shapes resemble the human form, making them a favorite among many artists. The next time you're at an art gallery or museum notice the ubiquitous pear as subject matter.

I have provided the photo that was my inspiration for this painting. Notice how my painting is an interpretation of the photo and not an exact copy. This is artistic license and personal expression at work. Rather than overlap the pears in a more traditional arrangement, I had fun lining them up. Note, however, that they are not lined up on the bottom edge of the page!

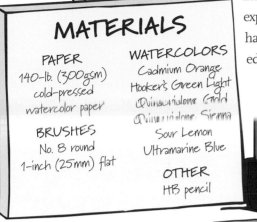

MATERIALS

PAPER
140-lb. (300gsm) cold-pressed watercolor paper

BRUSHES
No. 8 round
1-inch (25mm) flat

WATERCOLORS
Cadmium Orange
Hooker's Green Light
Quinacridone Gold
Quinacridone Sienna
Sour Lemon
Ultramarine Blue

OTHER
HB pencil

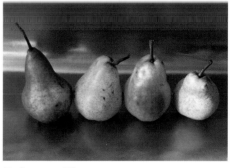

Reference Photo

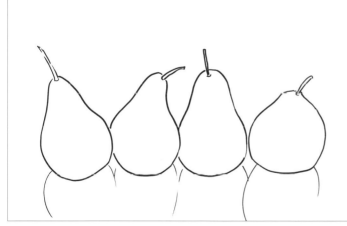

1 Sketch Pears
Lightly draw the four pears on your paper. For a variation on this project, place a single pear on your paper and paint it.

2 Lay a Graded Wash for the Background
Using your 1-inch (25mm) flat, create the background with a graded wash. Start at the top of the paper with a juicy mixture of Sour Lemon + Quinacridone Gold, working the paint all the way down and around the pears. A few strokes of color can go over the pears, leaving some areas of white paper. Let this dry.

Without disturbing the first layer of color, lightly re-wet the background, being careful to avoid the pears. Immediately place a juicy stroke of Quinacridone Sienna at the top of the paper using your 1-inch (25mm) flat. Tilt the paper so the color will run toward the base. You can assist the graded wash by using your brush, or you can allow gravity to pull the paint down gradually. Let your paper dry.

3 **Add First Glaze**
On dry paper, use your no. 8 round to loosely place Sour Lemon + Hooker's Green Light on pears one, two and four. Place only a small amount of this mixture on pear three. Soften a few edges with water and allow your paper to dry again.

Once dry, place a small amount of Quinacridone Gold + Cadmium Orange on pears one and three, softening some edges with water.

4 **Establish Form**
Using your no. 8 round, place Quinacridone Sienna + Ultramarine Blue on pear one. Brush Hooker's Green Light and Ultramarine Blue + Sour Lemon on pears two, three and four. Let this dry.

5 **Create Cast Shadows**
Draw the shapes of the cast shadows with water using your no. 8 round. While wet, apply Ultramarine Blue followed by Cadmium Orange on the shadow for pears one, three and four, and Ultramarine Blue followed by Sour Lemon for the second pear's shadow. If these cast shadows look too hard once they are dry, gently soften a few edges with a damp 1-inch (25mm) flat. Let this dry.

6 Add Final Touches

Add Ultramarine Blue to the right side of the pears using your no. 8 round. Soften a few edges that appear too harsh with clean water. On pear four, place the blue on the left side as well. Let this dry.

Shape the stems with a fairly dry mixture of Ultramarine Blue + Quinacridone Sienna. To create the shadow on the right side of the stems, apply Ultramarine Blue. Then, place a very dry mixture of Ultramarine Blue + Quinacridone Sienna on the pears to represent a few understated speckles of texture.

PEAR LINE-UP
7 ½" x 11" (19cm x 28cm)

DEMONSTRATION
Flowerpot With Oranges

This colorful still life is easier to paint than it looks. Start with a basic angled cylinder for the flowerpot and spheres for the oranges. The cloth is suggested by just a few simple strokes of color. The flowers are loosely suggested as well. Just breathe deeply and have fun with this!

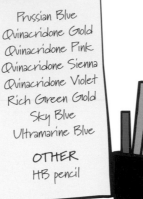

MATERIALS

PAPER
140-lb. (300gsm) cold-pressed watercolor paper

BRUSHES
No. 8 round brush

WATERCOLORS
Halloween Orange
Indian Yellow
Lemon Yellow

Prussian Blue
Quinacridone Gold
Quinacridone Pink
Quinacridone Sienna
Quinacridone Violet
Rich Green Gold
Sky Blue
Ultramarine Blue

OTHER
HB pencil

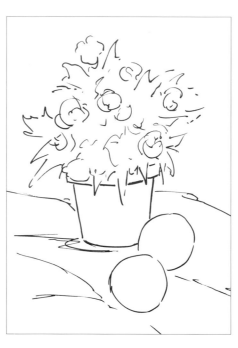

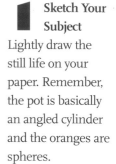

1 Sketch Your Subject
Lightly draw the still life on your paper. Remember, the pot is basically an angled cylinder and the oranges are spheres.

3 Build Glazes
Wet the oranges, flowerpot and flowers with clean water. Leave a few areas of dry paper. While wet, apply Indian Yellow to the oranges and flowerpot. Drag some of the color out from each of the oranges and the flowerpot toward the left to suggest a cast shadow. Let this dry.

Paint the flowers with Quinacridone Pink. While the pink paint is still wet, drop a small amount of water on top of each flower and blur a few edges to loosen and shape each flower. Keep flowers similar, yet vary them in shape and gesture. Allow this to dry.

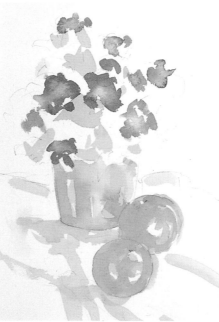

2 Lay a Base of Juicy Yellows
Lay a juicy mixture of Lemon Yellow + Quinacridone Gold on the flowers, pot, oranges and cloth. Let your paper dry.

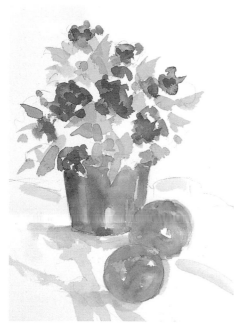

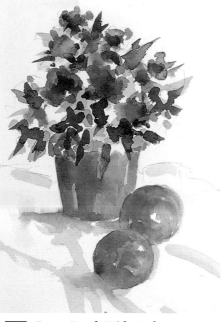

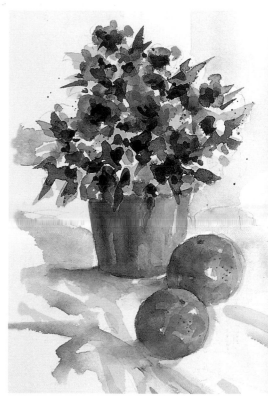

4 Add Leaves and Additional Glazes

Wisp Rich Green Gold throughout the flowers, leaving some white showing. Let this dry. Moisten the far left and right side of the flowerpot. Place Quinacridone Sienna on the wet areas. Pull some of this color to the left for a cast shadow.

Once the paper dries, add another glaze of Quinacridone Pink on the flowers. Soften some edges with water. Add another glaze on the oranges using Halloween Orange. Soften a few edges and let your paper dry once again.

5 Create Depth With Darks

Apply Rich Green Gold + Prussian Blue + Quinacridone Sienna on dry paper to create dark areas in the leaves. Wisp out at the end of the leaves to create the leaf shape. Let this dry.

Place Quinacridone Sienna on the oranges. While the Quinacridone Sienna is still wet, add Ultramarine Blue + Quinacridone Violet, allowing the colors to slightly mix on the paper. Wet the left side of the flowerpot with clean water. Add Ultramarine Blue + Quinacridone Pink to the saturated area. Create a dark value in the flowers by adding Ultramarine Blue + Quinacridone Pink throughout the petals and leaves. Soften some edges with water.

6 Add Final Touches

Place a small amount of water on the left side of the flowerpot. While wet, add another layer of Ultramarine Blue + Quinacridone Pink. Repeat this, adding the water and color mixture for the left side of the oranges.

Create a dry mixture of Prussian Blue + Rich Green Gold + Quinacridone Sienna. Apply this dark mixture to the leaves. Place one final glaze of Ultramarine Blue + Quinacridone Pink on the flowers. Allow this to dry.

Apply a juicy mixture of Sky Blue to the background and foreground. Loosen some edges with water. Place a touch of the Sky Blue on the flowers and the flowerpot to tie the elements of the painting together. Place some Quinacridone Pink splatters on the flowers, protecting areas you don't want splattered with scrap paper or a paper towel. Place final touches of Indian Yellow on the right side of the oranges.

PINK FLOWERS WITH ORANGES
11" x 7 ½" (28cm x 19cm)

DEMONSTRATION
Pomegranates

I love pomegranates. They have such character. I took some artistic license with this painting and made them a much richer red than I observed from real life. Enjoy creating these great shapes!

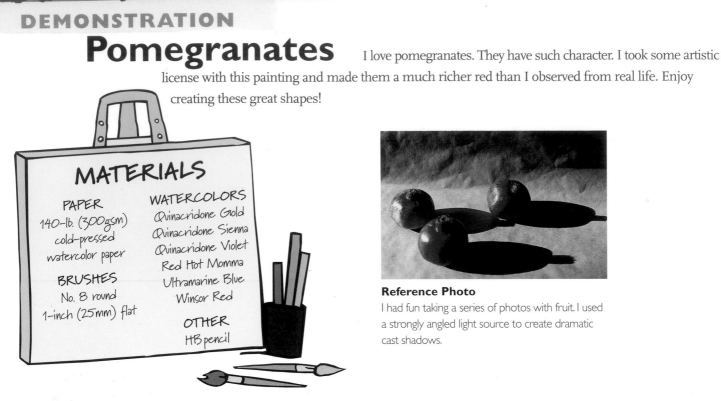

MATERIALS

PAPER
140-lb. (300gsm) cold-pressed watercolor paper

BRUSHES
No. 8 round
1-inch (25mm) flat

WATERCOLORS
Quinacridone Gold
Quinacridone Sienna
Quinacridone Violet
Red Hot Momma
Ultramarine Blue
Winsor Red

OTHER
HB pencil

Reference Photo
I had fun taking a series of photos with fruit. I used a strongly angled light source to create dramatic cast shadows.

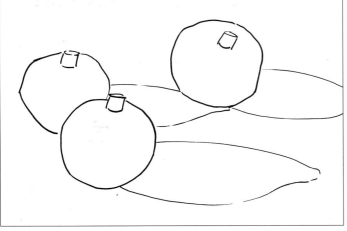

1 Sketch Pomegranates

Lightly draw the pomegranates on your paper. Start with basic spheres then modify them slightly. Pomegranates are not perfectly shaped spheres, so be sure to give them some character!

2 Paint the First Wash

Create the background wash with Quinacridone Gold and Quinacridone Sienna. Mix these colors on dry paper using your 1-inch (25mm) flat, and then blend them slightly by adding some clear water. Allow some of the strokes to cross into the pomegranates. Let your paper dry.

3 Establish the Red

Once the paper is dry, begin creating the pomegranates with Winsor Red using your no. 8 round. Try to leave some white highlights on the left side of the fruit. Allow your paper to dry again.

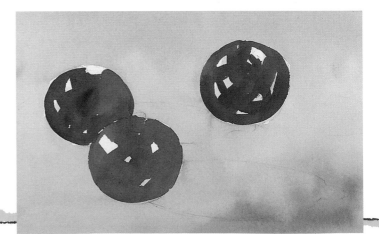

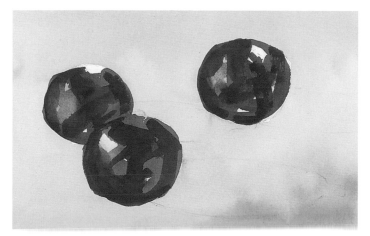

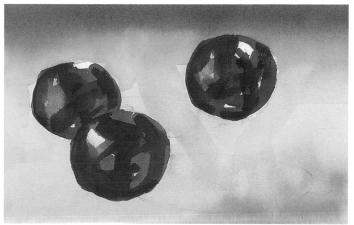

4 **Add Depth**
Create soft highlights on the left side of the fruit by lifting out some of the base color. Use a damp 1-inch (25mm) flat to help lift the color. Soak up water and color with a paper towel or facial tissue. Next, apply a glaze of Red Hot Momma + Winsor Red to the pomegranates using your no. 8 round. Work the color around the areas that were just lifted.

5 **Enhance the Background**
Wet the top of the paper with clean water using your 1-inch (25mm) flat. Try not to scrub. Just lightly place a stroke of water at the top. While still wet, place a stroke of Ultramarine Blue + Quinacridone Violet on your paper, pulling some of the color down using a graded wash technique. Then pull some of the color down into the composition with random strokes, avoiding the pomegranates. Tilt the paper to help the paint flow. Let this dry.

6 **Create Shadows and Details**
Create a lovely purple glaze of Ultramarine Blue + Quinacridone Violet. Apply this juicy mixture to the right side of the fruit using your no. 8 round. While this is still wet, drag the purple mixture down into the cast shadows. Apply a small amount of Winsor Red on the right side of the pomegranates, allowing a bit to become part of the cast shadow. This process hints at some reflective lights and also nicely bridges the subject and its shadow. Apply Ultramarine Blue + Quinacridone Violet on the right of the stems, using your no. 8 round. These are like mini-cylinders! Place a bit of Quinacridone Gold on the top and left sides of the stems. Place a few dark dots of the purple mixture on top of the stems.

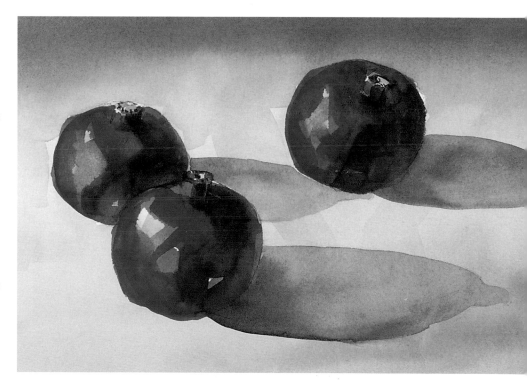

POMEGRANATES
7 ½" x 11" (19cm x 28cm)

Figures and Scenes

This chapter explores a variety of subject matter. You will learn how to create incidental figures, a simple portrait and finally, some everyday scenes. The projects incorporate many of the techniques and ideas that you've seen earlier, but prove more challenging to encourage your artistic growth. You will continue exploring such issues as composition, texture and negative space, while learning about several different approaches to style that you may want to use in your paintings.

Now that you are beginning to recognize the components of a strong composition, I challenge you to closely examine the art in this chapter and try to discern for yourself the elements that make each piece compelling. Observe color, focal point placement, repetition of shapes, use of positive and negative space and so on. By learning to identify good uses of design elements and principles, your own paintings are guaranteed to improve considerably!

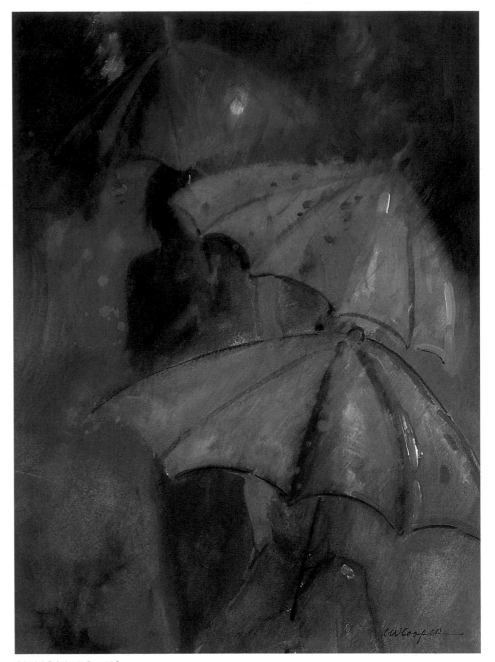

RAINY DAY IN BOONE
15" x 11" (38cm x 28cm)

Simple Figures

Simple incidental figures can add an additional layer of interest to your paintings, giving life to an otherwise ordinary scene. If appropriate, think about adding a distant figure to your next painting.

Creating a painting of a large group of simplified figures is fun as well. They can be placed in a market or city scene easily. First, though, practice creating an individual figure following the guidelines on this page.

MATERIALS

PAPER
140-lb. (300gsm)
cold-pressed
watercolor paper

WATERCOLORS
Quinacridone Pink
Ultramarine Blue

BRUSHES
No. 8 round

Simple Steps for Creating a Figure

Begin by creating the head. Load your no. 8 round with Ultramarine Blue + Quinacridone Pink, pushing down to create a human head with a short stroke.

Next, suggest shoulders and a torso with a back-and-forth stroke. Create a leg by pulling your brush downward.

Finish the figure, placing another stroke to suggest a second leg. If one leg is shorter it implies movement. Next add some simple arms. The limbs closest to you will appear larger by comparison.

WORDS TO KNOW

APPROACHES TO STYLE

There are three basic approaches to style: **realistic**, **abstract** and **non-representational**. Realism is concerned with representing the subject as it appears in life. Abstraction is a simplification or altering of the subject, yet the viewer may still recognize the subject. Non-representational paintings have no recognizable objects in them and are made up of lines, colors, patterns and textures. You will notice that some of the following demonstrations take the paintings just beyond realism. I encourage you to take such liberties in your paintings to help you grow as an artist.

Try Figure Possibilities

With a little practice, your figures can take on as much personality as you wish.

DEMONSTRATION
Simple Face

Practice drawing faces and then try painting one. This example is just a generic face. After much practice and observation, a generic face can be modified to actually look like a specific person. The painting then becomes a portrait of that person.

MATERIALS

PAPER
140-lb. (300gsm)
cold-pressed
watercolor paper

BRUSHES
No. 8 round

WATERCOLORS
Halloween Orange
Quinacridone Sienna
Quinacridone Violet
Ultramarine Blue
Winsor Red

OTHER
HB pencil

1 Sketch a Face
Lightly draw a face on your paper using your HB pencil.

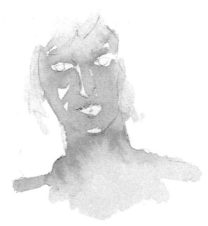

2 Underpaint Skin
For the skin create a watery mixture of Halloween Orange + Winsor Red + Quinacridone Sienna. On dry paper, apply this mixture to the face, neck and shoulders. Soften a few edges with clean water. Let this dry.

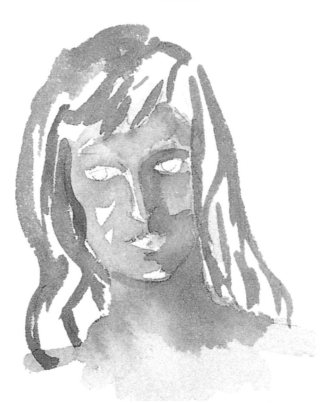

3 Paint Hair and Shade Face
Once the paper is dry, place Quinacridone Sienna on the hair and right side of the face. Allow your paper to dry again.

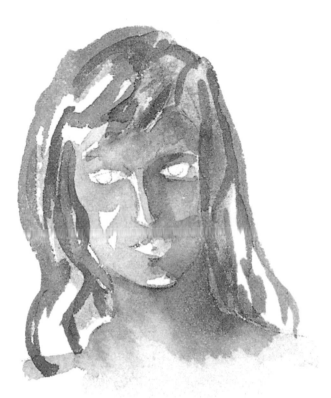

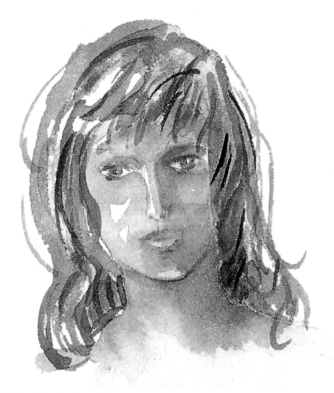

4 **Add More Shadows to Hair, Face and Neck**
Place Ultramarine Blue + Quinacridone Violet on the right side of the hair, face and neck. Add a small amount to the left side of the hair near the face. Keep this mixture fairly light by adding more water. Let your paper dry.

5 **Add Final Touches**
Place a small amount of water on the lips, then drop a touch of Winsor Red on them. Let this dry. The upper lip can be shaded with a small amount of Ultramarine Blue. Create the eyes with a dry mixture of Ultramarine Blue, outlining them slightly. Place Ultramarine Blue + Quinacridone Violet above the eyes to create a shadow under the brow bone. Place a very dark mixture of these colors on the pupils, softening just a bit with water if necessary. Add more streaks of Ultramarine Blue to the hair and do the same with Quinacridone Sienna.

House With a Fence

I sketched this charming home on a beautiful August afternoon in Arrow Rock, Missouri. I was sitting in an old-fashioned free-standing swing with my sketchbook, listening to the soothing sounds of summer. Every time I look at this sketch or painting I can still hear the horse in the paddock nearby and the whirring of bees around the flowers. This project focuses on painting foliage, creating an architectural structure and practicing the concept of negative painting.

MATERIALS

PAPER
140-lb. (300gsm) cold-pressed water-color paper

BRUSHES
No. 8 round

WATERCOLORS
Hooker's Green Light
Indian Yellow
Prussian Blue
Quinacridone Pink
Quinacridone Sienna
Quinacridone Violet
Rich Green Gold
Skip's Green • Sour Lemon • True Green
Ultramarine Blue
Winsor Blue
Winsor Red

OTHER
HB pencil

Reference Photo

1 Sketch the Scene
Lightly draw the house, fence and foliage and flowers.

2 Create the First Layer
Place a variety of light greens on the trees and shrubs, using the wet-on-dry method. Lose some of the edges. Alternate Hooker's Green Light, Rich Green Gold and Skip's Green all over the trees and shrubs. Allow this to dry.

3 Paint the Flowers and House
Place several drops of clean water where the flower blossoms will go. Then dot Indian Yellow, Quinacridone Pink and Winsor Red for the flowers. Loosely place them, trying not to fuss with them too much. Next, apply a light wash of Winsor Blue to the house.

4 Continue House, Foliage and Flowers

Place a juicy mixture of Ultramarine Blue + Quinacridone Violet on the roof. Adding a small amount of Quinacridone Sienna to the mixture will gray it slightly. The muted tone helps the roof recede into the background. Add another layer of color to the trees and shrubs. Mix Hooker's Green Light + True Green + Quinacridone Sienna and apply this mixture randomly to the foliage as well as a lively dose of Sour Lemon. Add some of the same greens to create stems and leaves for the flowers in the foreground.

5 Highlight the Fence Using Negative Space

To emphasize the fence, reinforce the darks around it. Create a dark green mixture of True Green + Prussian Blue + Quinacridone Sienna and apply it near and around the fence. Avoid the tendency to just outline the fence. Add some of this same green to the flower stems in the foreground and near the roof on the right. Allow your paper to dry.

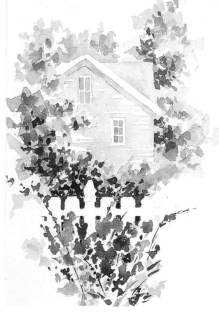

6 Add Final Touches

Darken the eaves and place shadows on the windows with Ultramarine Blue + Quinacridone Pink + Quinacridone Sienna. Let this dry before moving on.

Paint a watery Winsor Blue on the fence post to indicate a bit of shadow. Place Rich Green Gold on the foliage and some more of the same dark green mixture used in step 5 near the roof. Placing a dark next to a light helps the roof pop out. Add a few branches in the foliage using Ultramarine Blue + Quinacridone Sienna, and dab some more Winsor Red on the flowers to really help them stand out in the painting.

ARROW ROCK HOUSE
11" x 7 ½" (28cm x 19cm)

Porch Chairs

These porch chairs give you the perfect opportunity to practice more negative painting. The negative space between the back slats of the chairs was painted in darker colors than the chairs themselves. Painting behind the chairs enabled them to come forward and helped define their shape. As you can see from the photo, I edited out many of the small details in my interpretation. I wanted a slightly abstract look to the painting, so I simplified it.

Use a 1-inch (25mm) flat for the majority of the painting. To maintain a loose style, work as long as you can with your largest brush. Use your smaller brush for finishing details. Placing an intermittent outline around a shape will help the shape stand out from its surroundings, as you will see in the final step.

MATERIALS

PAPER
140-lb. (300gsm)
cold-pressed
watercolor paper

BRUSHES
No. 8 round
1-inch (25mm) flat

WATERCOLORS
Cobalt Teal Blue
Hooker's Green Light

Quinacridone Gold
Quinacridone Pink
Quinacridone Sienna
Quinacridone Violet
Skip's Green • Sky
Blue • True Green
Ultramarine Blue

OTHER
HB pencil

Reference Photo

1 Sketch the Chairs
Lightly draw the scene on your paper.

2 Paint First Wash
On dry paper, apply Quinacridone Gold then Quinacridone Pink in broad random strokes using your 1-inch (25mm) flat. Let your paper dry.

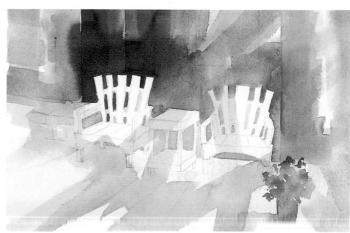

3 Apply More Colors

Using your 1-inch (25mm) flat, paint stroke next to stroke around the table and chairs, changing colors often. Use Cobalt Teal Blue, Sky Blue, Ultramarine Blue and Ultramarine Blue + Quinacridone Violet, adding water to help the paints flow into one another somewhat. Try not to just stripe the colors, and remember to vary the stroke size. If some colors mix on the paper this is fine, but be careful not to overmix. Allow the colors to stand on their own in places.

4 Create Flowers and Continue Background

With your no. 8 round, place a few small dabs of clean water where you would like the flowers to be, then drop in Quinacridone Pink and Quinacridone Gold. Allow this to dry.

Next, place some Quinacridone Sienna on the flowerpot and drag a cast shadow toward the left. Drop in a touch of Cobalt Teal Blue to cool the color. Let this dry.

Add Ultramarine Blue + Quinacridone Pink around and near the chairs using your 1-inch (25mm) flat at first, then switch to your no. 8 round for tighter areas. Let this dry.

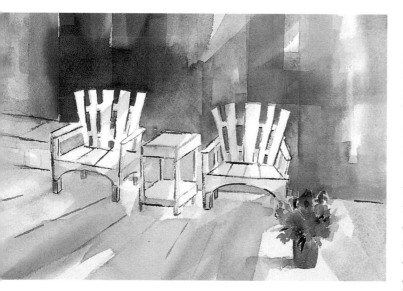

5 Add More Glazes and Darker Values

Lightly place some water on the flowers with your no. 8 round, then drop in more Quinacridone Pink and Quinacridone Gold. Next, use Hooker's Green Light, Skip's Green and True Green to create the foliage in the flowerpot. Let this dry.

Add more dark values of the Ultramarine Blue + Quinacridone Pink mixture to the background to help the chairs pop out more. Let your paper dry once again.

Wash Quinacridone Gold over parts of the chairs to diminish their stark whiteness using your 1-inch (25mm) flat. Shade the tables and chairs with Cobalt Teal Blue. To create a slight outlining effect, use the tip of your 1-inch (25mm) flat. Alternate between Cobalt Teal Blue and Ultramarine Blue + Quinacridone Pink for variety in lines. There should be only a small amount of water in your brush when outlining. Don't outline every edge; just define some of them. Allow your paper to dry.

Place a few more strokes of Cobalt Teal Blue to strengthen and unify the painting using your 1-inch (25mm) flat. Add a few more swipes of Quinacridone Gold to the flooring. Finally, paint a juicy mixture of the Ultramarine Blue + Quinacridone Pink under the chairs and on the flowerpot.

EARLY MORNING PORCH
7 ½" x 11" (19cm x 28cm)

Fountain

My friend has this wonderful fountain in the entry garden area of her old barn. The wildflowers, honeysuckle and poppies are a treat for the soul in this tranquil country setting and inspire creativity.

When painting the fountain, I simplified the scene by choosing to leave the background white. I eliminated all but the essentials to make a simple statement about the beauty of the fountain.

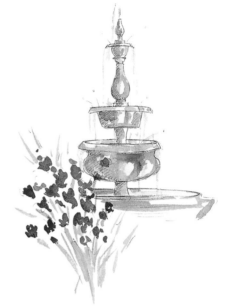

1 Sketch the Fountain

Sketch the fountain with your felt-tip pen. If you prefer, you can lightly draw the scene in pencil first and then go over the lines with your felt-tip pen. If you choose to do this, be sure to erase any pencil lines later.

2 Establish Color

On dry paper, apply Quinacridone Sienna to the fountain and soften some edges with water. Place Winsor Red and Red Hot Momma on the foreground poppies. Allow your paper to dry.

3 Enhance Colors

Use a watery mixture of Winsor Blue to create the water in the fountain. Place a variety of greens on the stems and leaves of the poppies, using Quinacridone Gold and Quinacridone Gold + Hooker's Green Light.

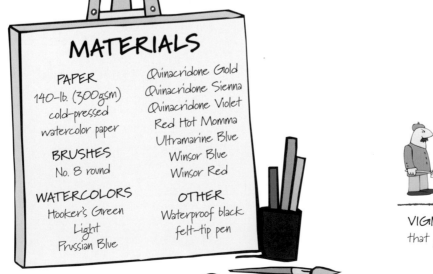

MATERIALS

PAPER
140-lb. (300gsm) cold-pressed watercolor paper

BRUSHES
No. 8 round

WATERCOLORS
Hooker's Green Light
Prussian Blue

Quinacridone Gold
Quinacridone Sienna
Quinacridone Violet
Red Hot Momma
Ultramarine Blue
Winsor Blue
Winsor Red

OTHER
Waterproof black felt-tip pen

WORDS TO KNOW

VIGNETTE A type of composition that gradually fades off toward the edges.

4 Form Shadows and Strengthen Color

Create the fountain shadows with Ultramarine Blue + Quinacridone Violet. Reinforce the Quinacridone Sienna on the fountain. Let this dry.

Restate the Winsor Red on the poppies and drop in a dry mixture of Ultramarine Blue + Quinacridone Violet for the dark centers. Add more of the same greens used in step 3 to the flower stems. Define the foliage with a darker green mixture of Hooker's Green Light + Prussian Blue.

5 Add Final Touches

Use more Winsor Blue to define the fountain water and place more Quinacridone Sienna on the base of the fountain. Deepen the foliage color with Winsor Blue + Quinacridone Gold + Quinacridone Sienna. Allow this to dry.

Next, place streaks of Quinacridone Gold throughout the foliage. Add a few more dabs of Red Hot Momma on the poppies. Reinforce the pen sketch lines all over the painting. In addition to the outlining, place some parallel lines for additional shading. Use the pen to shape a few flowers also.

RUANN'S FOUNTAIN
11" x 7 ½" (28cm x 19cm)

DEMONSTRATION
Arched Doorway

This old doorway has a great deal of character. The flowerpots are also a nice touch in the painting and help soften the overall linear quality of the scene. As in previous demonstrations, I took artistic license and interpreted the scene into a more abstract version. For this doorway, I simplified shapes and chose arbitrary colors. The perspective in this painting may feel a little intimidating, but give it a try. Notice how all the vertical lines are parallel to the sides of the paper and that perfectly horizontal lines are scarce. Almost every line that is not vertical is angled. Since it is an abstraction, you can skew some angles and lines and exaggerate shapes.

Reference Photo

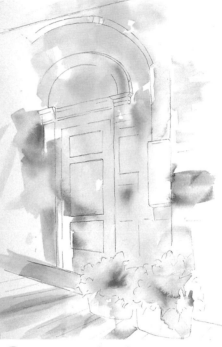

1 Sketch a Plan
Draw the doorway and flowerpots with your felt-tip pen. If you use a pencil first, be sure to erase any lines afterward.

2 Lay In Initial Washes
Wet the paper in random strokes with your 1-inch (25mm) flat. Then apply several strokes of Quinacridone Gold, Quinacridone Pink and Winsor Blue, allowing them to mix somewhat on the paper. Let this underpainting dry.

MATERIALS

PAPER
140-lb. (300gsm) cold-pressed watercolor paper

BRUSHES
No. 8 round
1-inch (25mm) flat

WATERCOLORS
New Gamboge
Opera
Quinacridone Gold
Quinacridone Pink
Turquoise
Winsor Blue

OTHER
Waterproof black felt-tip pen
Mat board

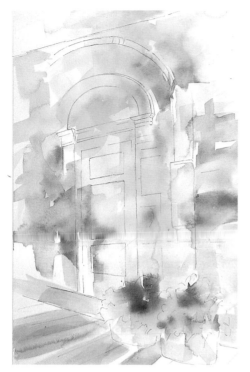

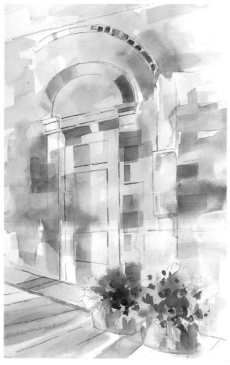

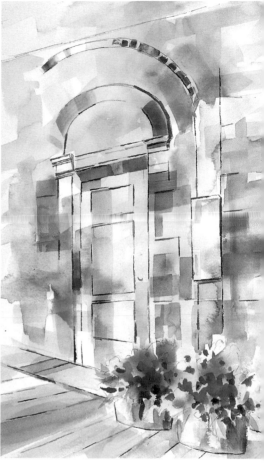

3 Add Brighter Washes

Lay a loose, random wash of clean water using your 1-inch (25mm) flat. Try not to scrub or disturb your first layer of color. While wet, place some strokes of New Gamboge, Opera and Turquoise. Allow these to mix slightly on the paper. Soften a few of the hard edges to help the layers mingle with each other. Let this dry.

4 Make the Doorway Appear Abstract

Using your 1-inch (25mm) flat, place strokes of Turquoise in abstract patches on and around the door and then allow this to dry. Repeat this process using Quinacridone Pink followed by New Gamboge. These glazes create a sense of depth.

Use a small, flat piece of mat board or cardboard (about 1/4-inch [6mm] wide) to apply small bricks on the arch above the door. Use the mat board just like a brush Using your flat brush, outline the structures with a few dark lines of Turquoise to help add definition.

On the flowerpots, use the corner of your flat brush for the leaves, wisping them out at the ends. Load your no. 8 round with Opera + Turquoise, squiggling this mixture on some of the foliage to create depth and shadows. Also place some of this mixture on the flowerpots themselves. Let this dry.

5 Add Final Touches

Place more Turquoise in areas all over the painting using your 1-inch (25mm) flat. Again, let your paper dry.

Next, add a few more strokes of New Gamboge for zest, also letting this dry before moving on.

Mix Turquoise + Opera to create the dark violet color for outlining. Using the tip of your flat brush, add a few more lines. Add more Opera to the mixture above and continue making a few lines. Also place some of your dark violet mixture on the flowerpots to tie all of the elements of the painting together.

DOORWAY
19" x 12" (48cm x 30cm)

Textures

Texture is one of the five basic elements of design that has been mentioned throughout the book. This chapter now gives it the full spotlight. In several of the previous projects, texture and texture-making techniques have been introduced and incorporated into paintings. This chapter further demonstrates methods of creating texture and explains how it can enhance a painting by adding variety and layers of interest. Although this book cannot possibly cover the entire scope of watercolor textures, it does offer an idea of some of the possibilities. Each texture featured in this chapter has multiple uses, so let's start exploring!

OLD CABIN
12" x 18" (30cm x 46cm)

Creating Textures

The texture-making techniques on the next several pages explore the use of many mediums. Several of the methods discussed, such as using plastic wrap or foil, have unpredictable outcomes. Other techniques, including stenciling and calligraphy, will produce more controlled results. Regardless the tool you use to create texture in your paintings though, the unveiling is always exciting!

Aluminum Foil

Just like plastic wrap, you can place aluminum foil over a variegated wash while it is still wet to create texture. Creasing the foil somewhat will enhance the outcome. After placing the creased foil on wet paper, place a book or something of substantial weight on top of the painting to increase the pressure over the foil. Wait a few hours (or even a day) before removing the book and foil to ensure a reaction. The paper may still be damp, so allow it to dry or use a hair dryer to speed the process. Once dry, you can further enhance the texture by adding a dark value to some of the resulting pattern.

Plastic Wrap

Use plastic wrap for rocks, grasses, cloth and experimental textures. First apply a juicy color to wet paper. While the paper is still very wet, firmly place a slightly crumpled piece of plastic wrap on the surface. Create a sharp-edged texture by allowing the paper to almost completely dry before removing the plastic wrap. Don't use a hair dryer to speed the drying process, though—the plastic will melt and stick to your paper.

Cheesecloth

If you're interested in creating a woven look on the surface of your paper, cheesecloth is the perfect texture-making tool. Begin by floating in some beautiful colors using a large amount of water. While wet, spread the cheesecloth on top of the paper. Let your surface dry and peel the cheesecloth off the paper, revealing a textured surface.

Calligraphy

You can also use calligraphy to create texture in your paintings. Outlining subjects in an expressive manner adds definition and boldness to paintings. The calligraphy can be long, short, choppy or a collection of dotted lines.

Collage

A collage consists of additional papers glued to a painting's surface. In this example, bits of colored tissue papers and textured rice papers were glued over a foil-textured base. To secure the bits of paper, I applied matte gel medium under and over the bits (white glue works as well). After the collage dried, some of the rice paper was enhanced with darker color in the negative spaces. Some dragging was used (pulling clean water over color while it is wet), as well as stamping with a film canister and mat board.

Stencil

In this example, I used a plastic needlepoint backing material from a fabric store as my stencil. I first laid the material on a lighter dried base color. I then loaded my 1-inch (25mm) flat with paint and swiped it over the plastic, creating a pattern. You can always make your own stencils with heavy cardstock paper and scissors or a craft knife. Paper doilies work well also.

OTHER TEXTURE-MAKING TOOLS

In addition to the tools discussed in this chapter, there are many other materials you can use to create texture. Consider using burlap, sponges, corks, bubble wrap, strings, credit card fragments and even paper towels to add interesting texture to your paintings.

Gesso

Gesso provides an unusual surface for watercolor.
Apply white gesso to dry paper in random strokes
leaving some of the paper untouched. Let this dry.
Note that the strokes you use to apply the gesso
will show through when you apply the color to
the paper later. When painting over dried gesso,
the gessoed areas will take the paint differently
than the untouched paper. Gesso resists the paint
slightly, but not entirely. Gessoed surfaces allow
paint to be removed very easily. Be sure to rinse
your brush well after using gesso since it is an
acrylic polymer emulsion.

Multiple Textures

This example combines stencilling, stamping and
dragging. I also applied some metallic Interference
Lilac paint on the surface for added interest.

Splattering With Gouache

In this example, I first applied a layer of violet to
the paper and allowed it to dry. I then loaded my
brush with white gouache and rapped the brush
on a pencil to release the splatters. The more
water in your brush the larger the splatters will be.
This method works well for snow, rain and stars
or for giving a slight mystical feeling to a scene.

WORDS TO KNOW

GESSO A textured and porous
acrylic-based polymer emulsion typically
used as a ground. Gesso comes in many
colors, white being the most common.

Painting Salt Flowers

Salt is great for creating textures such as flower masses, sandy beaches, rocks and snowflakes. You can use it creatively in many areas of your painting. Various types of salt (table, sea salt, kosher, rock and so on) will each react differently on your paper, creating different textures.

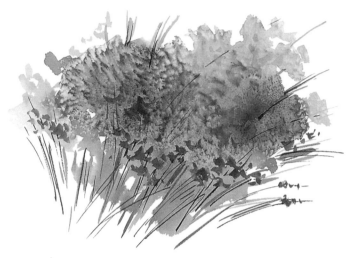

1 Lay In Color and Add Salt

Place clear water in the middle portion of the paper. Then, drop in Opera, Sour Lemon and Winsor Red on top of the water to create the flowers. While the paper is still wet, place Skip's Green, Rich Green Gold and Hooker's Green Light just below the flowers. Some of the flower colors may mix slightly with the greens. Then, place a few random wisps of these same greens to indicate grass and stems. While all of the colors are still damp, lightly sprinkle table salt over the flower area. Allow your paper to dry, then lightly brush the salt off using your hand.

2 Add Finishing Touches

Add darker values of Opera, Sour Lemon and Winsor Red to selected areas of the flowers. Allow your paper to dry.

Using Opera and Indian Yellow, place a darker value in the flower area. Be careful to group some of the darker values to avoid a polka-dot approach. Just below the flower mass and along some of the edges, place some individual flowers. For more stems, place a dark green mixture of Phthalo Green + Quinacridone Sienna around the painting. Weave some of the green stems through the flower mass.

JENNIFER'S CELEBRATION
7 ½" x 11" (19cm x 28cm)

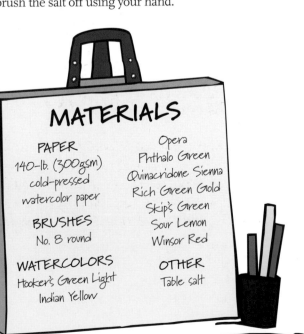

MATERIALS

PAPER
140-lb. (300gsm)
cold-pressed
watercolor paper

BRUSHES
No. 8 round

WATERCOLORS
Hooker's Green Light
Indian Yellow

Opera
Phthalo Green
Quinacridone Sienna
Rich Green Gold
Skip's Green
Sour Lemon
Winsor Red

OTHER
Table salt

QUICK TIP

SALTING YOUR PAPER

If no reaction happens with your salt, there may have been too much water on your paper, causing the salt to simply dissolve. Conversely, your paper could have been too dry when the salt was applied. It's all in the timing!

Creating Flowers With Alcohol

When rubbing alcohol is dropped into a wet color, it pushes the paint around in a circular motion. You can use alcohol to create texture for flowers, tree trunks, rocks, skies or experimental paintings. When using rubbing alcohol, it is best to pour a small amount into a different container and apply with an old brush or eye dropper.

MATERIALS

PAPER
140 lb. (300gsm)
cold-pressed
watercolor paper

BRUSHES
No. 8 round
1-inch (25mm) flat

WATERCOLORS
Opera
Phthalo Green

Pomegranate
Quinacridone Pink
Quinacridone Red
Rich Green Gold
Ultramarine Blue
White gouache

OTHER
Eye dropper
Rubbing alcohol

QUICK TIP

APPLYING ALCOHOL

A dropper works well to apply alcohol to your paper. Droppers are available at most pharmacies. Another idea is to recycle a small eye drop bottle. Be very careful to re-label any container that is being re-used for another purpose with first aid tape and a permanent marker.

1 Apply a Variegated Wash and Alcohol
Wet the entire surface of your paper using your 1-inch (25mm) flat. While wet, drop in Pomegranate, Quinacridone Red, Opera and Quinacridone Pink. Tilt your paper in a variety of directions to blend the colors. While the paper is still wet, place small drops of rubbing alcohol over the surface. Tilt the paper again and the alcohol will force the paint to go around it. Let this dry.

2 Create Petals
Once the paper is dry, the dried alcohol drops will serve as the flower centers. Using your no. 8 round, create petals by placing Quinacridone Red and Opera around the drops of alcohol. Add water as you apply the petals to soften edges. While wet, add a few more drops of alcohol on the petals to create another layer of texture. Let this dry.

3 Add Green Leaves

Using your no. 8 round, apply wisps of clean water around the perimeter of the flower mass wherever you would like some green leaves. Next, add Rich Green Gold + Phthalo Green to create a warm green. Place this color over the water in wispy leaf-like strokes. This will create just a hint of a leaf. If your leaf edges seem too harsh or look pasted on, continue softening edges with water to help them blend into the pink flowers. If your leaves get too pale or lost entirely, you can restate them later by repeating the process when your paper dries.

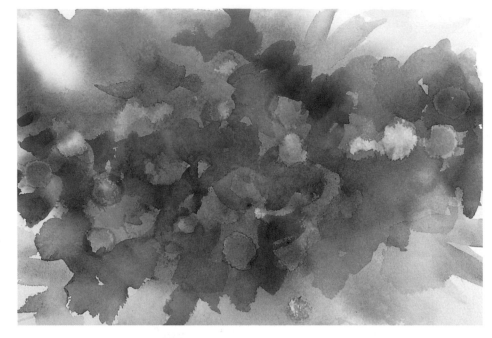

4 Add More Depth

Place some water on the petals where a darker value is preferred using your no. 8 round. Next, place Opera + Ultramarine Blue on these areas to create a slight value change and help create shadow and depth. Again, if these edges seem too harsh, soften them with water. Allow your paper to dry.

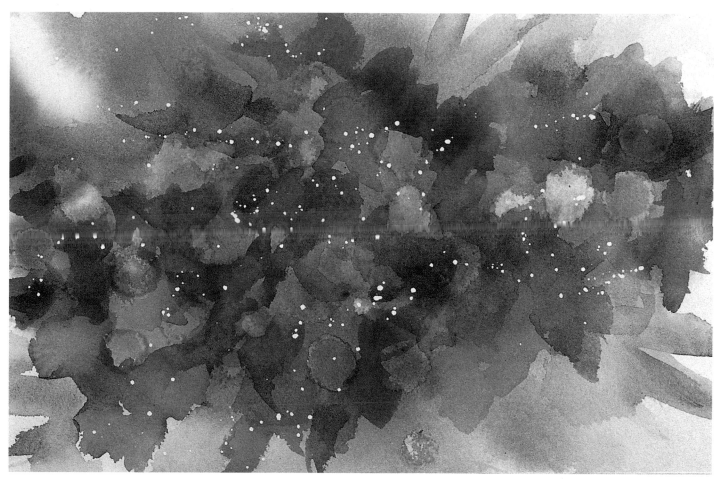

5 Add White Splatters

Using your no. 8 round, splatter some white gouache over the flowers to create a dewy morning effect.

MINA'S FLOWERS
7 ½" x 11" (19cm x 28cm)

Splattering Water and Color

Splattering is a great way to add a splash of texture to your painting. There are many variations in the application of splatter. Wet color or water splattered on wet paper will have a soft-textured effect. When applied to dry paper, the splatters will be more distinct.

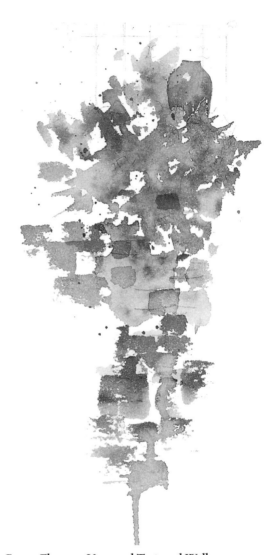

1 Sketch a Scene
Using your pencil, lightly draw the large vase on a balcony with overhanging flowers and foliage.

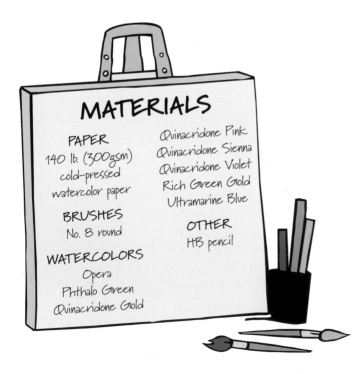

MATERIALS

PAPER
140 lb. (300gsm) cold-pressed watercolor paper

BRUSHES
No. 8 round

WATERCOLORS
Opera
Phthalo Green
Quinacridone Gold
Quinacridone Pink
Quinacridone Sienna
Quinacridone Violet
Rich Green Gold
Ultramarine Blue

OTHER
HB pencil

2 Create Flowers, Vase and Textured Wall
On dry paper, apply Quinacridone Gold, Quinacridone Pink and areas of Phthalo Green + Rich Green Gold to the flower section of your paper. Immediately splatter the wet area with each color just used. When the glisten is down, splatter with clear water. This should give a nice combination of colors and textures and suggest flowers cascading over a balcony. Let this dry.

Next, apply Quinacridone Sienna to the vase, leaving a small white highlight near the center. Then, using the side of the brush and a drybrush technique, create a suggestion of bricks and stones for the wall using the same color. Apply Quinacridone Sienna + Quinacridone Gold over some of the wall texture as well. Force an intentional drip toward the bottom for dramatic purposes. Allow your paper to dry.

3 Enhance Flowers With Splattering

Apply Quinacridone Pink followed by Quinacridone Violet to the flower area. While damp, splatter water onto the flowers, then immediately splatter the same colors over this. While this is still wet, apply Phthalo Green + Rich Green Gold to the foliage. Splatter water over this as well. Let your paper dry once again.

4 Add Final Details

Line the sides of the vase with a small amount of water. Next, place a thin layer of Ultramarine Blue on the wet edges of the vase helping to give it roundness and shadow. Let this dry.

For the flowers, mix Quinacridone Pink + Ultramarine Blue to create a darker value. Glaze the flowers with this mixture, allowing some of the first layer of paint to show through to feature a variety of values. Add Phthalo Green + Quinacridone Sienna for dark shadows on the leaves. Let your paper dry.

Add a darker glaze to some of the stones with a mixture of Quinacridone Sienna + Ultramarine Blue. Use the side of your brush in a drybrush technique for a rough-textured effect. Use a very dry mixture of Ultramarine Blue + Quinacridone Sienna to paint the iron fence detail. Add more greenery in general if you wish or splatter a few more dots of Opera.

LA ROMITA BALCONY
11" x 7 ½" (28cm x 19cm)

Making Plastic Wrap Leaves

Using plastic wrap as a texture-maker is a handy tool for watercolorists. As mentioned earlier in the book, plastic wrap can be used instead of a brush for creating foliage and other textures. In this demonstration, the plastic wrap is used quite differently. The angular textures made by the plastic wrap are used solely as an underpainting—a base upon which to build. After applying subsequent glazes, the beautiful textured base is allowed to show through in places.

For this project, you will use leaves as the subject of the painting. Any subject can be substituted, though, as long as it has a distinct silhouette. For fun, create a series of paintings using different colors and subjects over the textured base.

MATERIALS

PAPER
140-lb. (300gsm) cold-pressed watercolor paper

BRUSHES
No. 8 round

WATERCOLORS
Cobalt Blue
Cobalt Teal Blue
Phthalo Green

Quinacridone Sienna
Sour Lemon
Ultramarine Blue

OTHER
HB pencil
Plastic wrap
Spray bottle
Tree leaves (optional)

WORDS TO KNOW

SILHOUETTE A distinct outline of an object or a person.

1 Create an Underpainting
Create a clean, bright variegated wash using Sour Lemon, Phthalo Green and Cobalt Teal Blue. Tilt the paper to help blend the colors, spritzing the paper with a spray bottle if necessary to help the colors move. While wet, lay a slightly crumpled piece of plastic wrap over the surface and press with your hand to secure the folds and creases. Allow this to air dry. For hard-edged creases, the paper should air dry almost completely. After about ten minutes, you should have a reaction, but the creases will be soft-edged if the plastic is removed too soon. After a reaction has occurred, remove the plastic and allow your paper to dry completely.

2 Draw the Leaves
Use a pencil to lightly trace around actual leaves or practice your drawing skills by creating them freehand.

3 Lose the Edge

Working a small section at a time, place some water on the outside edge of one of the leaves. While wet, begin placing a variety of dark greens and blues on the outside edge of the leaf using Phthalo Green + Quinacridone Sienna, Cobalt Blue and Ultramarine Blue. Add more water and color as you work around the outside of the leaf.

As you work, lose the edge of your paint line by feathering it out with clear water to the edge of your paper. This allows some of the unique underpainting to show through. Be careful not to simply outline or ring your subjects with a dark paint color with hopes of feathering out later. The staining nature of some paints will not be agreeable to that! Just work a small area at a time to be safe.

4 Add Final Details

Continue to carry the cool dark colors around the outside of the second leaf losing edges as you proceed. Be sure to vary your values and colors. I chose to leave the finished painting with no other embellishments, but feel free to use your artistic license, creating a variation on the project.

COOL AUTUMN
7 ½" x 11" (19cm x 28cm)

QUICK TIP

LOSING THE EDGE

To lose an edge, blend the edge of a paint line with either more paint or clear water so that a dry line is not detected. The term **feathering out** means the same thing.

Dragging to Create Reflections

Dragging your wet brush over wet or dry color will produce a variety of effects. You can drag with color or with water only. Notice that dragging is different from glazing, as most often a loosening and blending occurs.

It takes courage to drag your brush over a wet area of color. Experiment with this and see what effects you can create! In this particular project you will use dragging to produce a water effect with reflections.

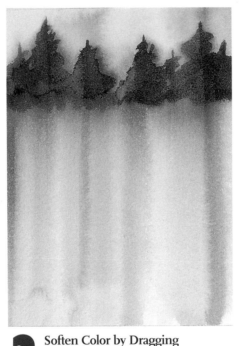

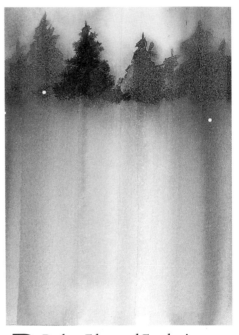

1 Establish Trees

On dry paper with your no. 8 round, paint a row of evergreen trees varying the height and width. Create the green by using Phthalo Green + Quinacridone Sienna.

2 Soften Color by Dragging

While the trees are still wet, drag or pull a clean, damp 1-inch (25mm) flat over the trees starting at the top of the paper and ending at the base of the paper. This will not only soften the colors, but will also create the illusion of water. Immediately paint a few vertical strokes of Quinacridone Gold as well. Let this dry.

3 Darken Edges and Emphasize Focal Point

On dry paper, drag Cobalt Blue over the far left and right margins using your 1-inch (25mm) flat. Place a few strokes of clean water to help blend the blue with the painting.

While your paper is still damp, use your no. 8 round to restate one of the trees which will be your focal point. Use a fairly dry mixture of Phthalo Green + Quinacridone Sienna for this tree. Let your paper dry.

MATERIALS

PAPER
140-lb. (300gsm) cold-pressed watercolor paper

BRUSHES
No. 8 round
1-inch (25mm) flat

WATERCOLORS
Cobalt Blue
Phthalo Green
Quinacridone Gold
Quinacridone Sienna
White gouache (optional)

4 Create Drama by Lifting Lines

Using the tip of a damp 1-inch (25mm) flat, lift out a horizon line where the trees meet the water. Notice that this line is broken. Next, lift out a vertical line for dramatic flair indicating a ray of light. To complete the illusion of water, lift a few more random horizontal strokes all the way down the paper in the water area.

5 Add Splatters for Finishing Touches

This last step is optional. It gives the painting another layer of texture to increase interest. Use your no. 8 round and white gouache for splatters.

MORNING MEDITATION
7" x 5" (18cm x 13cm)

DEMONSTRATION
Drybrushing a Fence

The drybrush technique can be used in many ways. However, this highly controlled method of painting is most often used to create detailed realistic works. With regards to texture, though, drybrush affords the artist a wide range of possibilities, such as wood-grain effects, grasses and weeds. Here you will utilize the drybrush technique to paint pumpkins.

1 Create a Sketch
Lightly draw the scene on your paper with your HB pencil.

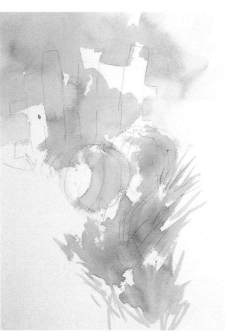

2 Underpaint Scene
On dry paper, apply a generous amount of Quinacridone Gold over part of the sky, fence, pumpkins and foreground grasses using your 1-inch (25mm) flat. While wet, place some Cerulean Blue in the sky, adding water to loosen the color and help lose the edges. Let this dry.

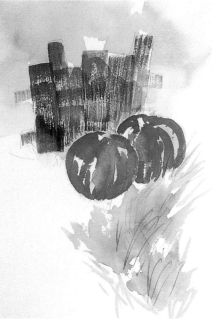

3 Establish Textures
Using your 1-inch (25mm) flat and very little water, drybrush Burnt Sienna + Ultramarine Blue on the fence in vertical strokes.

Next, using your no. 8 round, place a mixture of Indian Yellow + Winsor Red on the pumpkins. Leave some white paper on the left side to create highlights. Add a few wisps of the orange mixture to create the foreground grasses.

MATERIALS

PAPER
140-lb. (300gsm) cold-pressed watercolor paper

BRUSHES
No. 8 round
1-inch (25mm) flat

WATERCOLORS
Burnt Sienna
Cerulean Blue
Indian Yellow
Prussian Blue
Quinacridone Gold
Quinacridone Pink
Quinacridone Sienna
Ultramarine Blue
Winsor Red

OTHER
HB pencil

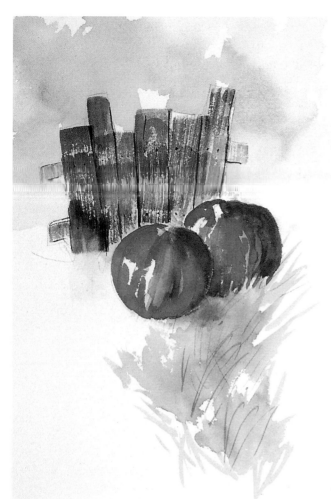

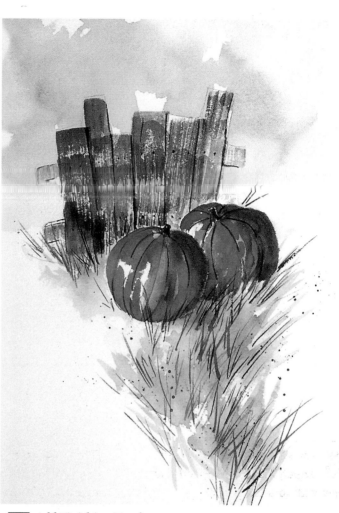

4 Place More Details

Use your no. 8 round and any dark mixture of your colors to create lines that separate fence slats and nail holes. Then, using a clean, damp 1-inch (25mm) flat, soften the bottom edge of the fence slat on the left to help blend it with the ground. Next, wet the right side of the pumpkins and place Ultramarine Blue + Quinacridone Pink on the shadow side of them. Place a small amount of water in the grass area to create the cast shadow from the pumpkins. Place the violet mixture to the right of the pumpkins on the ground, dropping a touch of the orange mixture into the shadow for warmth. Let this dry.

5 Add Finishing Touches

Using your no. 8 round, place a little water in the grass then some Cerulean Blue on top of it to bridge the color from the sky to the foreground. Let this dry.

Drybrush a variety of colors into the foreground for the grass. Use Indian Yellow + Winsor Red, Quinacridone Sienna + Ultramarine Blue + Quinacridone Sienna. In the background under the fence, place a small amount of water followed by a small amount of Quinacridone Gold. Place some curved lines on the pumpkins using a mixture of Prussian Blue + Quinacridone Sienna. Use this color for the stems as well. Let this dry.

Protect the sky with scrap paper. Use your no. 8 round to splatter your choice of colors for some extra texture in the foreground.

SWEARINGENS' PUMPKINS
11" x 7 ½" (28cm x 19cm)

Conclusion

Watercolor painting is a journey, not a destination. Learning and growing are part of the journey. Keep an open mind on your journey and incorporate new ideas into your own personal style. Keep a sketchbook, constantly honing your skills as an artist. Learning to draw better will translate into better paintings. It will also sharpen your powers of observation. Take in information. Run it through your own sensibilities, keeping what works for you and discarding the rest.

Read, study, practice, take courses and workshops—it will enrich your experience, understanding and appreciation for art. No education is ever wasted, as there is something to be gleaned from each and every experience. All information is leading you in your own personal artistic direction. Your personal style is dynamic, not static. It grows and changes as you do.

The very nature of watercolor begs us to take risks. Go with the flow of your paintings. Instead of always trying to force a painting into a preconceived idea, try working with the painting you have. Many times our paintings will tell us where they want to go. It's okay if some paintings say, "I'm collage material." That's still a direction!

All art forms have a certain amount of inherent frustration. That is part of the creative process, so keep your courage. There is always struggle in transformation. I hope the information in this book has helped you to begin your own watercolor experience. Watercolor's endless possibilities await you!

"I never made a painting as a work of art. It's all research."

Pablo Picasso

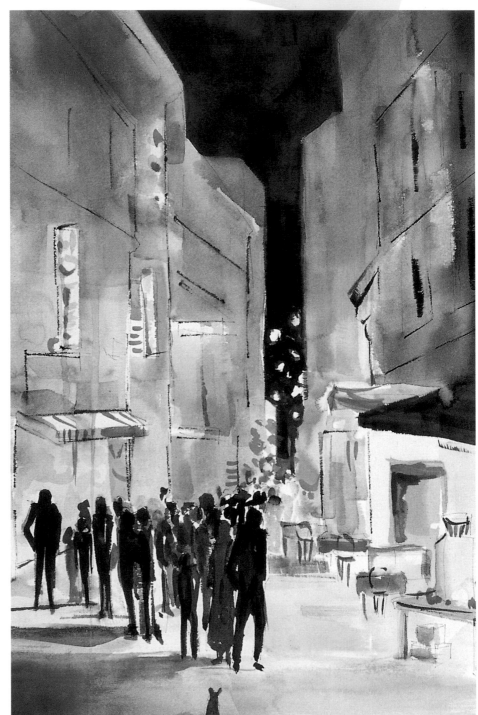

PARIS NIGHT
13" x 9" (33cm x 23cm)

Glossary

Acid-free Paper or material with a pH of 7 (ideal). If paper has a pH less than 7, it will eventually lose whiteness and decay.

Analogous Colors Closely related colors adjacent to each other on the color wheel.

Artistic License The ability and permission to change, alter or edit a composition in any way you wish.

Atmospheric Perspective In painting, objects in the distance appear duller, cooler and lighter.

Bloom (also backwash or cauliflower) Occurs when wet paint is merged into another partially dry color or damp paper, resulting in an unusual color or texture.

Cast Shadow An area that is darkened due to an object blocking that area from light. An object casts a shadow in the opposite direction from the light source.

Color Characteristics Hue, value, temperature and intensity.

Color Scheme A plan for the colors in your painting. Some choices are monochromatic, analogous, complementary, split complementary and so on. Choosing a rather short list of arbitrary colors is also considered a color scheme and is often referred to as a limited palette.

Color Wheel Consists of twelve colors: three primary, three secondary and six tertiary.

Complementary Colors Colors opposite each other on the color wheel. Using complements in your paintings is a great way to create contrast or emphasis, and combining complements creates grays.

Design Elements The basic elements are line, color, shape, value and texture. Sometimes included are size and direction. These are the building blocks of composition.

Dominant Direction Dominance is a principle of design which simply means more of something in a composition. Dominant direction refers to the prevailing angle of lines such as horizontal, vertical or diagonal.

Drybrush A brush that contains more paint than water. Great for fine detail and creating textures such as grasses, fences and tree trunks.

Earth Colors Technically these are colors that contain minerals from the earth. A few examples are Yellow Ochre, Raw Sienna, Burnt Sienna and Burnt Umber. Commonly this term is used to describe any color that is of an earthy nature (browns, golds, warm muted greens).

Edges Hard edges move forward in a painting while soft edges recede. Using a variety of edges helps create a sense of depth and perception in your paintings.

Ferrule Metal portion of a brush that holds the hairs to the handle.

Focal Point The center of interest (emphasis) in a painting usually created by contrast in color, value, shape and/or size.

Gator Board A rigid sheet of foam board covered with paper on both sides. It is widely used as a support board for watercolorists.

Gesso (acrylic-based) This is an acrylic polymer emulsion that comes in many colors, white being the most common. It is used as a ground on canvas or paper in many painting mediums. When used on watercolor paper it will allow the paint to be lifted off easily. It also provides an unexpected texture as a base in watercolor painting. It must fully dry before paint can be applied over it.

Glazing A thin layer of paint laid on top of another dried layer.

Gouache Opaque watercolor.

Granulation Sediment or coarse pigments in some paints. The sediment settles into the valleys of the paper and produces a grainy effect.

Horizon Line The imaginary line where the earth meets the sky. Also referred to as eye level.

Hue The generic name for a color on the color wheel.

Intensity The brightness (purity) or dullness (grayed quality) of a color.

Light Bounce The ability of light to pass through a dried layer of paint on paper and reflect back to the viewer. Transparent paint allows the most light bounce. Opaque paints do not allow light to penetrate their surface.

Lightfastness Level of permanence of a paint. Levels range from excellent (permanent) to fugitive (will fade).

Lose the Edge Feathering out a line of paint to blend it into the background. Also, varying the edges on a shape from hard to soft is considered losing the edge as well.

Mud Overmixed colors or incompatible mixtures that are dull and lifeless. This term is relative and not always necessarily negative. A dull color may do quite nicely in some situations!

Negative Painting Painting around a subject, usually with a darker value, leaving the subject lighter and defined by the background or negative space.

Negative Space Background space around a subject in the picture.

Neutrals True neutrals are black, white and gray. They are achromatic (without color). Neutrals are not included on the color wheel because they are not in the visible spectrum.

Opacity The inability of light to pass through the surface of paint and reach the white of the paper. If opaque paint is

laid over another layer of dried paint, the bottom layer will not be visible.

Outlining Creating a distinct line around all or some of a shape using paint to help define it.

Paint Properties Permanence (light-fastness), transparency, staining ability, temperature and granulation.

Palette A surface used for mixing. In watercolor, it is common to have a palette that holds the paint in individual wells and provides a mixing surface all in one. Palettes are usually plastic or enamel. The term palette can also refer to a group of colors used by an artist. Limited palette means that the artist is limiting herself to a small number of paint colors.

Plein Air A French term for painting outside.

Positive Space Positive space is the subject matter; negative space is the background.

Primary Colors Yellow, red and blue. From these colors, all other colors on the color wheel are created.

Principles of Design Compositional devices that help organize the elements in a design. Some of the basic principles of design include contrast, emphasis, dominance, balance, movement and repetition.

Rule of Thirds One method used for placing a focal point in a composition. Divide any size of paper into three sections horizontally and vertically. This creates nine rectangles or squares with four intersecting points. Choose one of those intersections to place your focal point.

Secondary Colors The colors that result from blending two primaries: orange, violet and green. Yellow + red = orange, red + blue = violet and yellow + blue = green.

Sediment Coarse particles that do not dissolve in some paints.

Silhouette A darkened shape that is recognized by its outline.

Snap The ability of a brush to bounce back to its original shape and position when wet. Brushes with no snap are a source of frustration.

Splatter (or spatter) Small specks or dots of paint or plain water that create texture. Tapping a loaded brush on a pencil or using a toothbrush are the most common application methods.

Staining The ability of a paint to soak down into the fibers of the paper and resist lifting.

Stylistic Approaches Certain ways of representing a subject. The three basic approaches are realism, abstraction and non-representation.

Temperature Coolness or warmness of a color. Greens, violets and blues are generally cool, while reds, yellows and oranges are generally warm. However temperature is always relative. Almost all paint color is pushed in a direction of warm or cool (e.g. Alizarin Crimson is a cool red).

Tertiary Colors (or intermediate) The colors that result from mixing a primary color with a secondary color: yellow-orange, red-orange, red-violet, blue-violet, blue-green and yellow-green.

Texture An element of design that helps add variety to a painting. Implied texture gives the illusion of a surface.

Tooth The texture of a painting surface. Three common types of watercolor paper are hot-pressed (smooth), cold-pressed (medium textured) and rough (heavily textured).

Transparency The ability of light to pass through a color. Transparent paints allow light to penetrate them and bounce off the white paper underneath back to the viewer's eye.

Underpainting Applying an overall wash on your paper as a preliminary step to a watercolor painting. A variegated wash will coax you into unusual color combinations and help you loosen up your style.

Value An element of design that refers to the lightness or darkness of a color or tone.

Value Sketch Placing lights, darks and midtones in a sketch, using a pencil or marker. This plan then can become a guide for placing lights and darks in a painting.

Viewfinder A small piece of matboard or cardboard with a small rectangle cut out of the middle, used to help one isolate possible compositions while viewing a scene.

Viewpoint The angle from which something is viewed (from above, from below, straight-on and so forth.)

Wash A watery layer of paint applied over a large area. The three types of washes are flat, graded and variegated. A flat wash has no variance in value. A graded wash moves from light to dark (or vice-versa) and has depth. A variegated wash is made up of a variety of different colors and values creating both depth and interest.

Wet-in-Wet A basic watercolor technique of placing wet paint on wet paper, creating soft edges.

Wet-on-Dry A basic watercolor technique of placing wet paint on dry paper, creating hard edges.

Index

The best in fine art instruction and inspiration is from North Light Books!

Beginning watercolorists will find all the simple, easy-to-follow instruction they need to paint a variety of gorgeous flowers, leaves and other foliage. Author Judy Eaton quickly brings you up to speed on the basics of getting started, then provides illustrations and step-by-step demos to ensure quick painting success.

ISBN 1-58180-235-8, paperback, 96 pages, #32010-K

Decorative painters and beginning artists alike will be introduced to watercolor materials and basic painting techniques illustrated through detailed mini-demos in this concise, easy to understand guide. Well-known watercolor designer Paul Brent will lead you through 13 complete step-by-step projects to create beautiful works of flowers, fruits, bees and butterflies that you'll be proud to showcase.

ISBN 1-58180-398-2, paperback, 128 pages, #32470-K

Packed with insights, tips and advice, *Watercolor Wisdom* is a virtual master class in watercolor painting. Jo Taylor illustrates every important technique with examples, sketches and demonstrations, covering everything from brush selection and composition to color mixing and light. You'll learn how to find your personal style, work emotion into your painting, understand and create abstract art and more.

ISBN 1-58180-240-4, hardcover, 176 pages, #32018-K

Nature paintings are most compelling when juxtaposing carefully textured birds and flowers with soft, evocative backgrounds. Painting such realistic, atmospheric watercolors is easy when artist Susan D. Bourdet takes you under her wing. She'll introduce you to the basics of nature painting, then illuminate the finer points from start to finish, providing invaluable advice and mini-demos throughout.

ISBN 1-58180-458-X, paperback, 144 pages, #32710-K

Find these and other great North Light titles at your local art & craft retailer, bookstore, online supplier or by calling 1-800-448-0915.